PASSIONATE PATRONS

VICTORIA & ALBERT AND THE ARTS

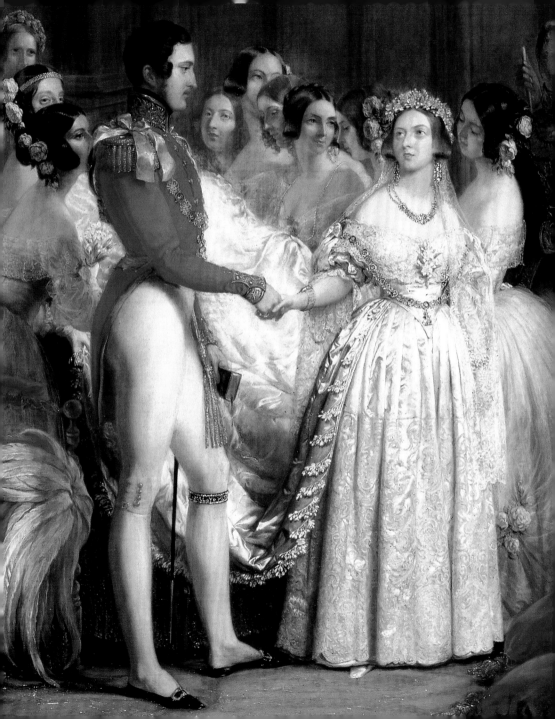

PASSIONATE PATRONS

VICTORIA & ALBERT AND THE ARTS

LEAH KHARIBIAN

ROYAL COLLECTION PUBLICATIONS

Published in 2010 by Royal Collection Enterprises Ltd
St James's Palace, London SW1A 1JR

in association with Scala Publishers Ltd
Northburgh House, 10 Northburgh Street, London EC1V 0AT

For a complete catalogue of Royal Collection publications, please write to
the address at top, or visit our website at www.royalcollection.org.uk

SKU: 012225
ISBN: 978 1 905686 33 9
British Library Cataloguing-in-Publication data:
A catalogue record of this book is available from the British Library

Written by Leah Kharibian
Typeset in Caslon
Designed by Nigel Soper
Project manager, Scala: Oliver Craske
Printed in the UK by Butler Tanner and Dennis Ltd
10 9 8 7 6 5 4 3 2

Every effort has been made to acknowledge correct copyright of images where
applicable. Any errors or omissions are unintentional and should be notified to the
Publisher, who will arrange for corrections to appear in any reprints.

Royal Collection Enterprises is grateful for permission to reproduce the following:
INSIDE COVER: © Design Archive Fabrics; Photograph The Royal Collection
© HM Queen Elizabeth II, 2010. PAGE 5: Door panel in the Council Room,
Osborne House. English Heritage; Photograph The Royal Collection
© HM Queen Elizabeth II, 2010. PAGE 150 (LEFT): © Crown copyright. NMR.

FRONT COVER: Franz Xaver
Winterhalter, *Queen Victoria*, 1843
(detail; p.35)

BACK COVER: Charles Brocky,
Prince Albert, 1841 (detail; p.21)

FRONT FLAP: Franz Xaver
Winterhalter, *The Royal Family in
1846* (p. 46)

BACK FLAP: Sèvres Manufactory,
Jean-Charles Develly and Pierre
Huard, *Casket*, 1842 (p. 152)

INSIDE COVER: Floral design
incorporating, in pink outline,
the profiles of Queen Victoria
and Prince Albert, based on the
bed hangings, sofa and curtains
in Queen Victoria's bedroom at
Osborne House. The original
design was created for the royal
yacht *Victoria and Albert* in the
1850s.

PAGE 2: Sir George Hayter, *The
Marriage of Queen Victoria*, 1840–42
(detail; pp. 28–29)

PAGE 190: Unknown maker,
*Butler's table at Osborne House,
c.*1872 (detail)
Inlaid olive wood

RIGHT: Painted door panel in the
Council Room at Osborne House,
1850s (detail).

CONTENTS

INTRODUCTION

QUEEN VICTORIA AND HER CONSORT, Prince Albert, shared a passion for
the arts. In their twenty-two years together – from their courtship
in 1839 and marriage in 1840, until the Prince's untimely death in
1861 – art played a key role in every aspect of their daily lives. As patrons and
collectors their tastes were exceptionally wide-ranging, taking in all types of
art from early Renaissance panel paintings to sculpture, furniture, jewellery,
miniatures, watercolours and the new art of photography. As a couple they took
a keen interest in the serious endeavours of cataloguing, conserving and
displaying both their new acquisitions and the magnificent inheritance of the
Royal Collection. But they enjoyed themselves immensely, too. A large
proportion of their purchases were bought as gifts for each other – often as
surprises. They took great delight in planning and participating in magnificent
balls and fancy-dress parties, musical evenings and theatrical performances.
And throughout their marriage they employed some of the most celebrated
painters, sculptors, composers and actors of the age. But most importantly,
Queen Victoria and Prince Albert were artists themselves. Even amid the
duties of state they found time to paint, etch, sculpt, design, compose and
perform music. And in everything they did, the theme of their mutual love and
devotion found constant expression.

SIR WILLIAM BEECHEY
(1753–1839)
*Victoria, Duchess of Kent,
and Princess Victoria*, 1821
Oil on canvas,
144.4 x 113.3cm
RCIN 407169

Here the two-year-old
Princess Victoria appears
with her mother, the
Duchess of Kent. Between
them the Princess clasps a
portrait of her father who had
died in January 1820.

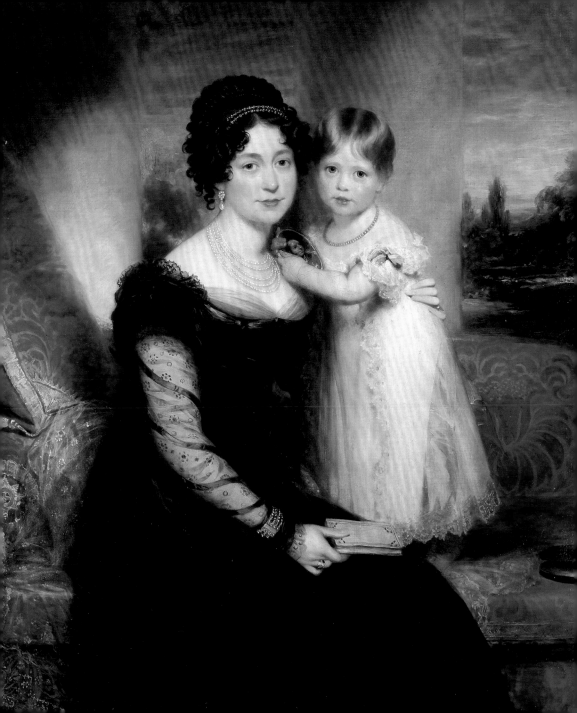

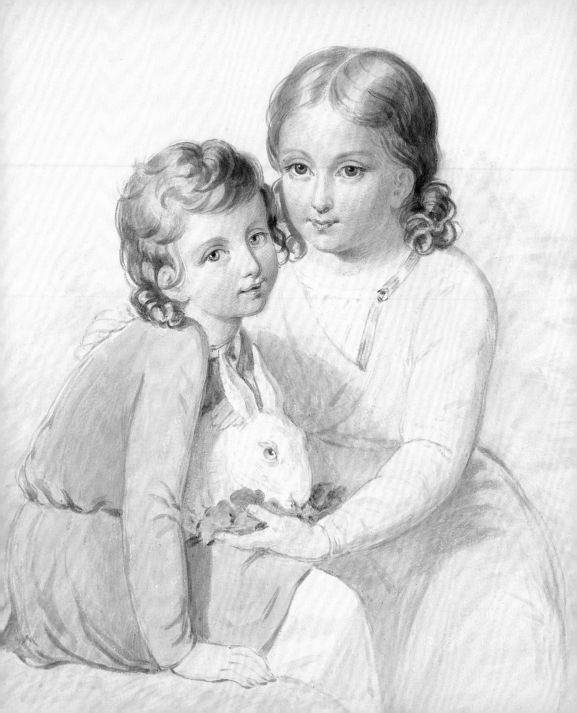

LEFT:

MAGDALENA DALTON,
née ROSS (1801–1874)
after LUDWIG DÖLL
*Princes Albert and Ernest of
Saxe-Coburg and Gotha in
1829, c.1846*
Watercolour, 29 x 22.7cm
RL 12109

Prince Albert appears on the
left at about the age of 10,
accompanied by his older
brother Ernest. The two
boys shared their education
and remained inseparable
until Prince Albert departed
for Italy.

EMIL WOLFF (1802–1879)
Prince Albert, 1839
Marble,
height inc. socle 59cm
RCIN 1527

This marble portrait bust
records the nineteen-year-
old Prince during his Grand
Tour of Italy. He took his
study of art seriously,
spending most of his six-
month stay visiting galleries,
churches, monuments and
artists' studios.

Queen Victoria and Prince Albert were first cousins, and had both been raised by a single parent (see *Family Tree*, pp.188–9). Queen Victoria, who was born at Kensington Palace on 24 May 1819, lost her father, Edward Duke of Kent, when she was only eight months old. Prince Albert of Saxe-Coburg and Gotha, who was born at the Rosenau, a miniature castle near Coburg, on 26 August 1819, was brought up by his father after his parents divorced when he was five. The Prince's father, Ernest, and Queen Victoria's mother (also Victoria) were brother and sister, and it was their sibling Leopold (1790–1865), later King Leopold I of the Belgians, who became the leading figure in family affairs. For both the young Princess Victoria in London and Prince Albert in Coburg, uncle Leopold played a vital role in shaping their early lives and education. He also pursued the long-cherished family ambition of bringing the two together in marriage.

Queen Victoria was heir presumptive to the throne from an early age and was educated at home. She showed a great aptitude for drawing and painting in watercolours as well as real talent for singing. Her early sketchbooks are filled with images of dancers and theatrical scenes, displaying her love for live performance. Her knowledge of fine art was chiefly drawn from the pictures she saw around her at Kensington Palace, at exhibitions she visited and from the collections of the great houses where she stayed with her mother. But she remained a little unsure of her taste, and made no purchases of her own. After her accession to the throne in June 1837, at the age of 18, her Prime Minister, Lord Melbourne, proved a decisive influence. The young Queen found Melbourne's advice invaluable in all matters, including art, and it was with his encouragement that she purchased her first oil paintings and took decisions about displaying the Royal Collection. He also gave her confidence in her opinions on art, which – as her Journals reveal – were often forcefully expressed.

Prince Albert's education was more complete and formal than that of his future wife. Until the age of 19 he was educated with his older brother Ernest, their studies taking them to Brussels and Bonn Universities. But in December 1838 the brothers parted company and Prince Albert embarked on a six-month

Grand Tour of Italy. The tour, which took him to Florence, Rome, Naples, Siena, Milan and Turin, had a profound impact on the Prince's taste in art. 'My range of observation has been doubled,' he wrote, 'and my power of forming a right judgement will be much increased by having seen for myself.' Prince Albert adored the landscape and art of Florence, but it was in Rome that he came into contact with the well-established colony of German artists, archaeologists and scholars who ignited what were to become life-long

CALDESI, BLANFORD & CO.
(active 1860s–1870s)
Ludwig Gruner, 1860
Albumen print, 8.9 x 5.6cm
RCIN 2913512

RIGHT:
LUDWIG GRUNER
(1801–1882)
*Part of a carved ceiling in the
Palazzo Vecchio at Mantua*,
from *Specimens of Ornamental
Art selected from the best works
of the Classical Epochs*,
London 1850
Chromolithograph with
hand colouring
RCIN 1192825

A key figure in the
development of Prince
Albert's taste in art, Ludwig
Gruner came to London
in 1841 where he served as
the Prince's artistic adviser
for the next fifteen years.
His scholarly studies in
ornamental design were
very influential, and he
played a major role in the
design schemes at many
of the royal residences.

passions: for the sixteenth-century Renaissance artist Raphael, and for sculpture. It was also in Rome that the Prince met the engraver, designer and occasional art-dealer, Ludwig Gruner (1801–1882). When Prince Albert travelled to London to marry Queen Victoria in 1840, Gruner soon followed, becoming the Prince's artistic adviser and the facilitator of many of the royal couple's most ambitious artistic schemes.

LOVE

I N LATER LIFE Prince Albert recalled that he had known from the age of three that he was to marry his cousin Victoria. But despite family wishes, it was not a foregone conclusion. At their second meeting, at the age of twenty, Victoria had become Queen to some twenty million subjects, while Prince Albert remained the second son of a Duke whose principality was less than half the size of the Isle of Wight. However, despite this disparity in rank, the Queen found that she and her cousin shared a passion for art and music, and that, coupled with a strong physical attraction, set the seal on what was to become an intensely loving relationship. From the moment of their engagement on 15 October 1839, an exchange of heartfelt gifts began. This established a pattern of gift-giving at birthdays, Christmas and on their wedding anniversaries, which continued throughout their married life and proved to be one of the chief ways in which the pair expanded their art collection. Love was often the theme of these presents. But sound economic sense also prevailed. The limits set on their annual incomes meant the Queen and Prince had a fairly modest budget for art, and so larger gifts were sometimes given in instalments. However, they each delighted in finding the object that would best please the other, regardless of its value, and in many instances the artistic hand of one or other of them is clearly present as creator, designer or composer.

ROGER FENTON (1819–1869)
*The Queen and Prince,
Buckingham Palace (After a
Drawing Room), May 11 1854*
Albumen print laid on paper,
20.4 x 16.2cm
RCIN 2906513

The Queen and Prince were early supporters of the new art of photography. This image was the first to show the Queen in her official role, as reigning monarch. Even so, the loving gaze she directs towards the Prince, who tenderly plucks a flower, has the romantic connotations of a wedding portrait.

PAGES 16–17:
THOMAS WOODRUFF
(*c.*1820–1902), maker;
LUDWIG GRUNER
(1801–1882), designer
*Console table, c.*1850 (detail)
Siena and other marbles,
lapis lazuli, malachite and
bronzed iron
RCIN 41007

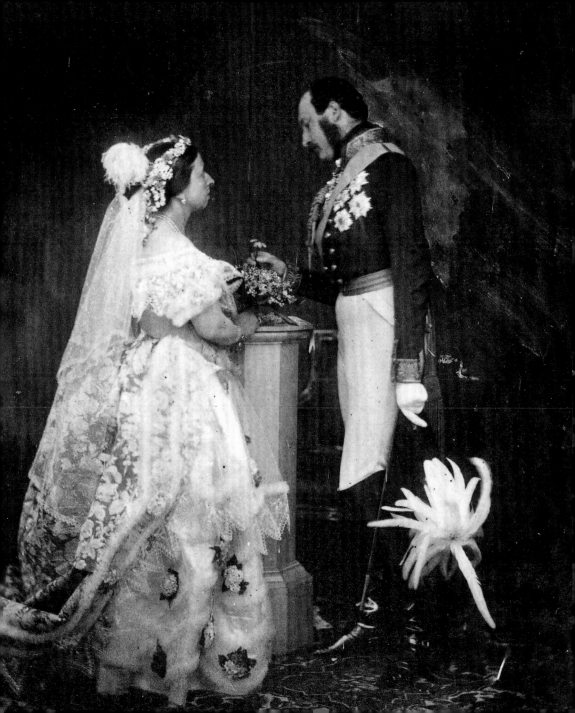

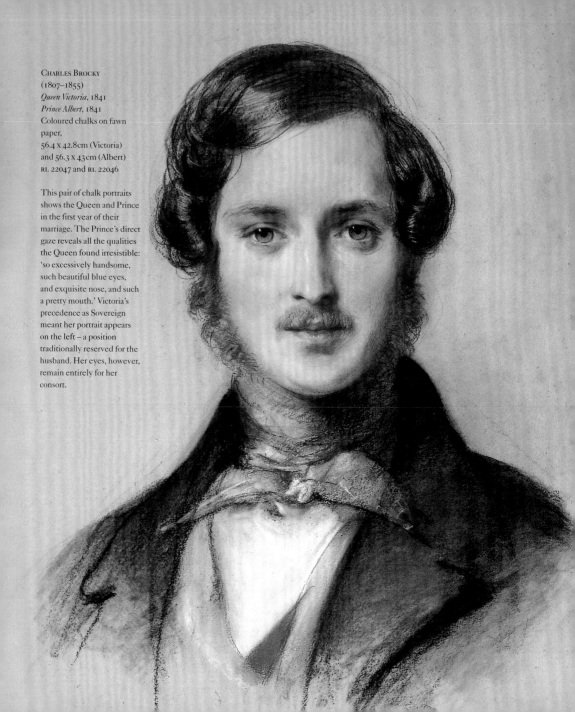

CHARLES BROCKY
(1807–1855)
Queen Victoria, 1841
Prince Albert, 1841
Coloured chalks on fawn
paper,
56.4 x 42.8cm (Victoria)
and 56.3 x 43cm (Albert)
RL 22047 and RL 22046

This pair of chalk portraits
shows the Queen and Prince
in the first year of their
marriage. The Prince's direct
gaze reveals all the qualities
the Queen found irresistible:
'so excessively handsome,
such beautiful blue eyes,
and exquisite nose, and such
a pretty mouth.' Victoria's
precedence as Sovereign
meant her portrait appears
on the left – a position
traditionally reserved for the
husband. Her eyes, however,
remain entirely for her
consort.

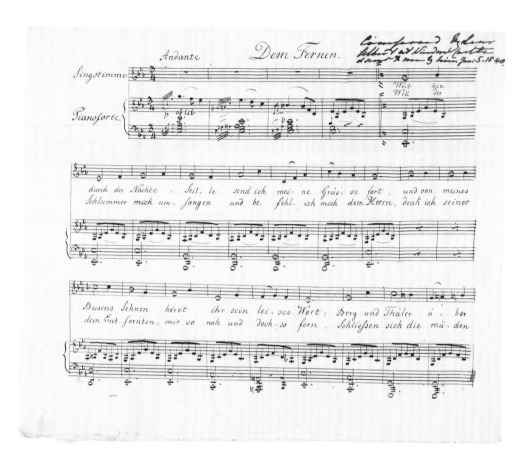

PRINCE ALBERT
Dem Fernen
(To the Distant One), 1839
Autograph manuscript on
paper, 22.9 x 27.6cm
RCIN 1140987

For the seventeen weeks of
their engagement, Prince
Albert returned to Coburg.
From there he sent the
Queen this manuscript of
one of the songs he had
begun composing while
with her in England.
A handwritten annotation

by the Queen at the top
of the first page reads:
'Composed by dear Albert
at Windsor Castle & sent
to me by him Jan. 5. 1840.'
The words of the song (see
translation opposite) tell of
a distant love yearned for
at night.

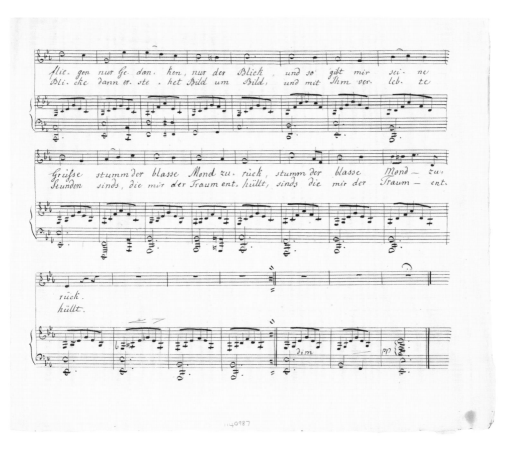

To the Distant One (a translation of *Dem Fernen*)

Far off into the dead of night
My greetings rise aloft
Till in my breast, by yearning pressed,
His calming voice speaks soft.
These peaks and vales I strain to cross
With leaps of mind and eye
In hopes that soon the stone-faced moon
Will echo his reply,
Will echo his reply.

If weary sleep must weigh me down
Then keep me, Lord, I pray.
Still pines my heart for him apart
So near yet far away.
At last sweet visions tumble in
As vision starts to dim,
And in my dreams, re-lived, it seems
The time I spent with him,
The time I spent with him.

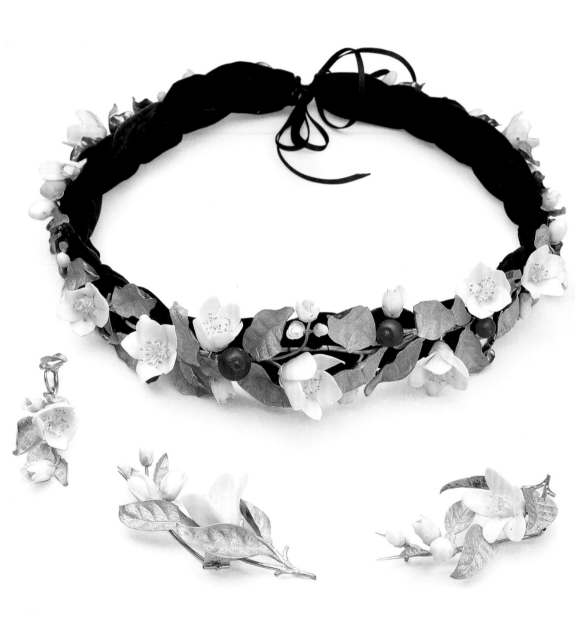

One of the first gifts Prince Albert sent his fiancée was a gold and porcelain brooch. It takes the form of a sprig of orange blossom, a flower traditionally associated with betrothal. At the wedding the Queen wore sprays of real orange blossom in her hair and on her bodice (see detail, p. 2). Prince Albert continued to give the Queen orange-blossom jewellery, eventually creating this beautiful set, parts of which she always wore on their wedding anniversary.

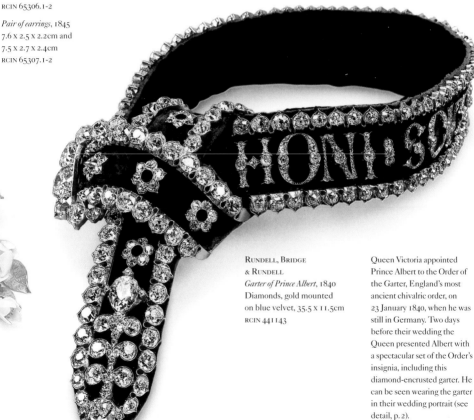

RUNDELL, BRIDGE
& RUNDELL
Garter of Prince Albert, 1840
Diamonds, gold mounted
on blue velvet, 35.5 x 11.5cm
RCIN 441143

Queen Victoria appointed Prince Albert to the Order of the Garter, England's most ancient chivalric order, on 23 January 1840, when he was still in Germany. Two days before their wedding the Queen presented Albert with a spectacular set of the Order's insignia, including this diamond-encrusted garter. He can be seen wearing the garter in their wedding portrait (see detail, p. 2).

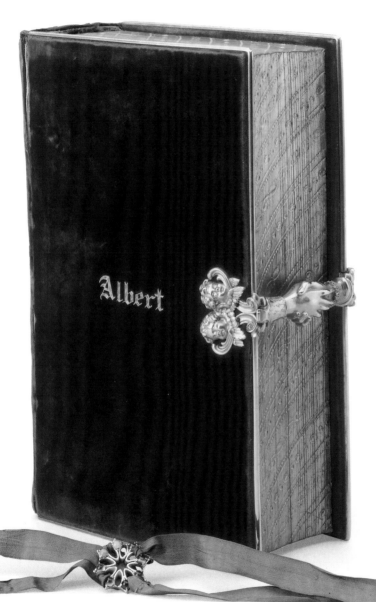

HON. CHARLOTTE GRIMSTON (1778–1830), compiler
The Form of Morning Prayer, according to the use of the United Church of England and Ireland,
6th edn, London:
J. Hatchard & Son; Oxford:
S. Collingwood & Co., 1837
Green velvet binding with gilt metal edges and clasp, jewelled bookmark,
16.4 x 10.6cm
RCIN 1129966, 98141

This velvet-covered prayer book was given to Prince Albert on his wedding day by his aunt and mother-in-law, the Duchess of Kent. The clasp showing the joined hands of a man and woman, emerging from clouds in which cherub's heads can be seen, plays on the idea of marriage as a sanctified union. At the Queen's insistence, the image of joined hands became the central focus of the royal wedding portrait (see pp.28–9).

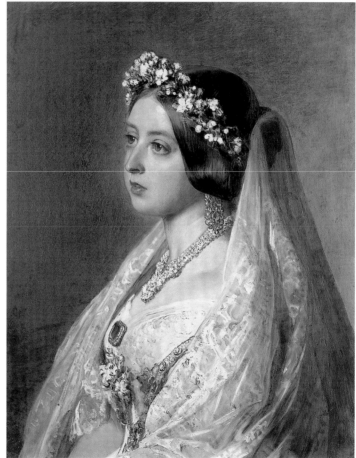

ENGLISH
*Queen Victoria's Wedding
Brooch*, 1840
Sapphire, diamonds
and gold, 3.7 x 4.1cm
RCIN 200193

FRANZ XAVER WINTERHALTER
(1805–1873)
*Queen Victoria in her wedding
dress in 1840*, 1847
Oil on canvas, 53.7 x 43.4cm
RCIN 400885

The day before their
wedding Queen Victoria
recorded a gift from 'dearest
Albert' of 'a splendid brooch,
a large sapphire set round
with diamonds, which is
really quite beautiful' (above,
shown larger than actual
size). The Queen wore the
brooch for the ceremony and
ensured that it featured
prominently in the portrait
she commissioned from
Winterhalter as a wedding
anniversary gift for the
Prince in 1847.

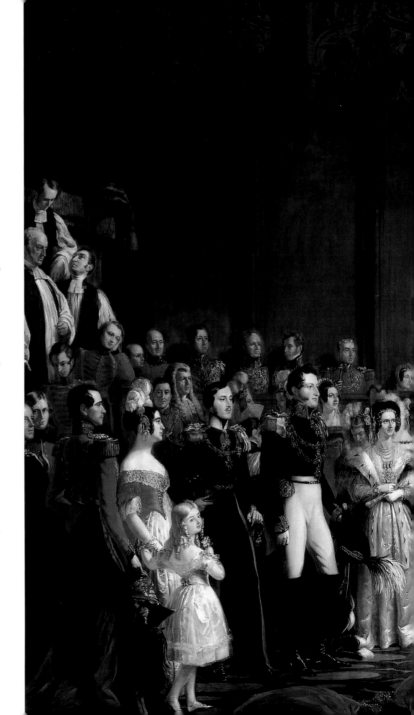

SIR GEORGE HAYTER
(1792–1871)
*The Marriage of Queen Victoria,
10 February 1840*, 1840–42
Oil on canvas,
195.6 x 273.4cm
RCIN 407165

Queen Victoria's marriage to
Prince Albert took place in
the Chapel Royal, St James's
Palace on 10 February 1840.
In her Journal the Queen
recalled: 'The Flourish of
Trumpets ceased ... and
the organ began to play,
which had a beautiful effect.
At the Altar, to my right,
stood my precious Angel.'
This picture, commissioned
by the Queen from Hayter,
shows the royal couple
taking their vows before the
Archbishop of Canterbury.
On the right near the Queen
stands Lord Melbourne
carrying the Sword of State,
and to the right of the
Archbishop stands the
Queen's mother. At the left
stands the Dowager Queen
Adelaide and 'Uncle
Leopold', King of the
Belgians.

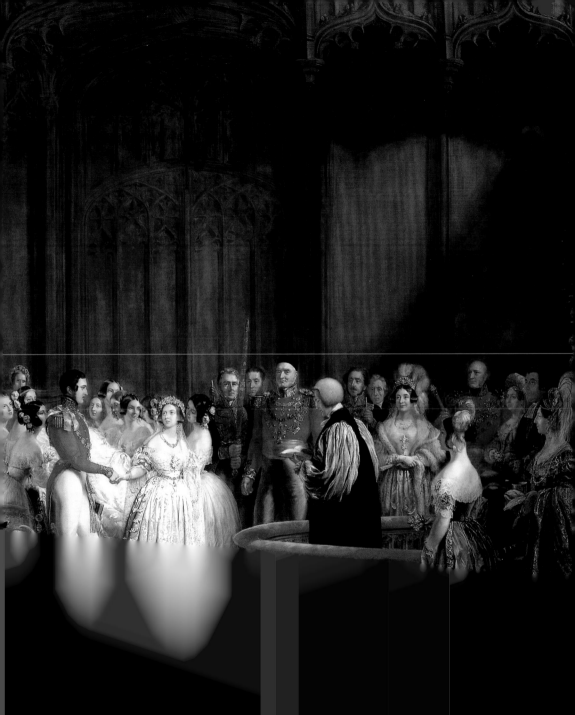

**ATTRIBUTED TO
R. & S. GARRARD & CO.**

Bracelet, 1841
Agates and gold,
18 x 1.5cm
RCIN 12453

Brooch, 1853
Agates and gold,
5.3 x 3.3cm
RCIN 12483

Bracelet, 1842
Agates and gold,
length 21.1cm
RCIN 13538

The Queen and Prince had
a great taste for sentimental
souvenirs. These pieces were
all made from pebbles the
couple collected on their
travels. The earliest of the
group (bracelet, top) was
made from stones picked
up during the couple's first
journey alone together in
the Summer of 1841.
The location of each find
(Brighton, Claremont,
Panshanger, Windsor,
Woburn Abbey for the
bracelets; Rapley for the
brooch) is engraved on the
mount.

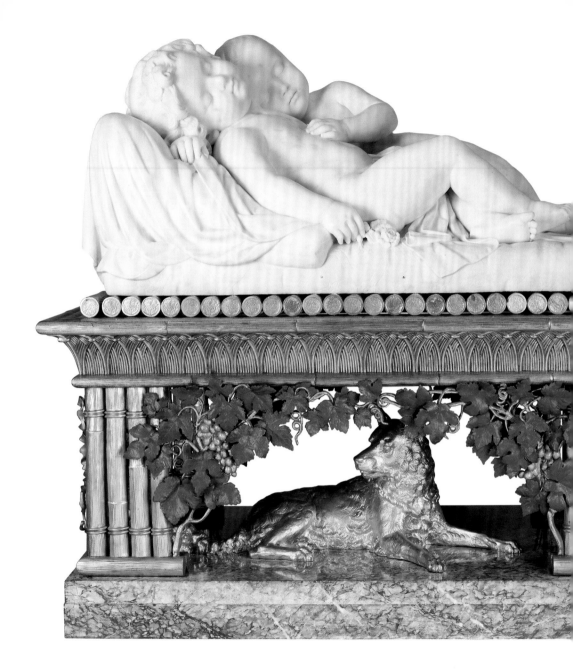

GUILLAUME GEEFS
(1805–1883)
Paul et Virginie, 1851
Marble,
40 x 80.6 x 41.9cm;
bronze stand,
40 x 93 x 55.2cm
RCIN 41033

The theme of love
dominated many royal
purchases. This marble
sculpture by the Belgian
artist, Guillaume Geefs,
was given to the Queen by
Prince Albert for Christmas
in 1851. The work depicts
the eponymous sweethearts
of Bernardin de Saint-
Pierre's book *Paul et Virginie*
as infants, blissfully asleep in
each other's arms. The base
of painted and gilded bronze
was made the following year,
and a year later still the gilt
bronze collie was added.

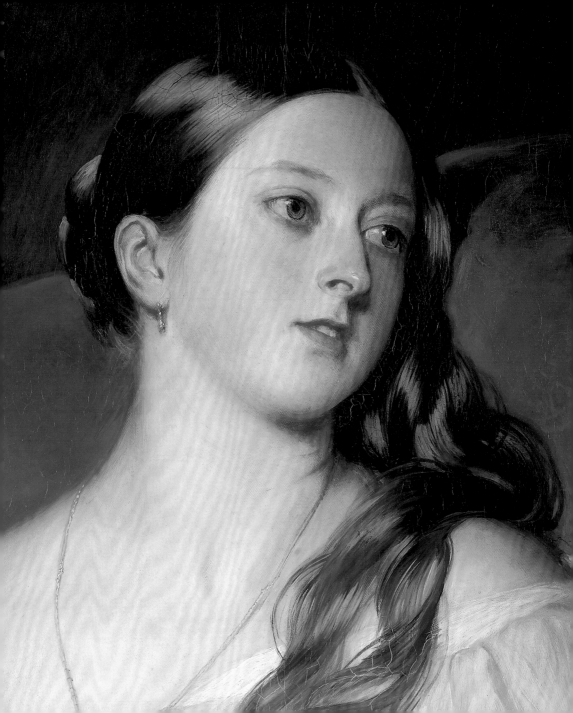

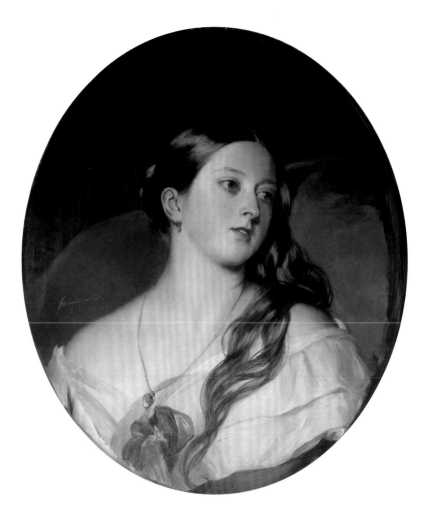

Franz Xaver Winterhalter
(1805–1873)
Queen Victoria, 1843
Oil on canvas, 64.8 x 53.4cm
RCIN 406010

Described as 'the secret
picture' by the Queen,
this intimate portrait
was commissioned from
Winterhalter as a surprise gift
for Prince Albert's twenty-
fourth birthday. In it the
Queen appears at her most
alluring, with bare shoulders
and her hair half undone.
She was delighted with its
reception. 'He thought it so
like, & so beautifully painted.
I felt so happy & proud to have
found something that gave
him so much pleasure.'

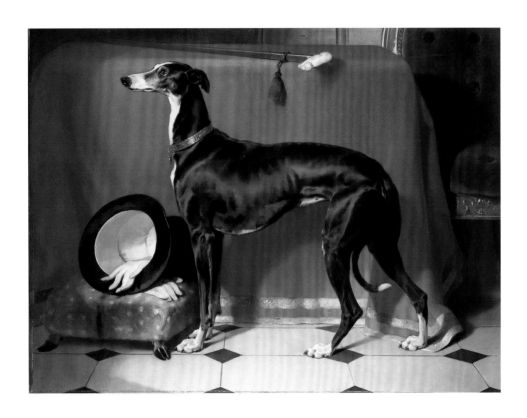

Sir Edwin Landseer
(1803–1873)
Eos, 1841
Oil on canvas,
111.8 x 142.9cm
RCIN 403219

Another surprise gift
organised by Queen Victoria,
this celebrated picture by
the famous animal painter
Landseer shows Eos, the
Prince's favourite greyhound
bitch. Eos stands alert, as if

ready to accompany her
master outside, while the
Prince's presence nearby
is suggested by his top hat
and gloves on the footstool,
and by his cane on the
table above.

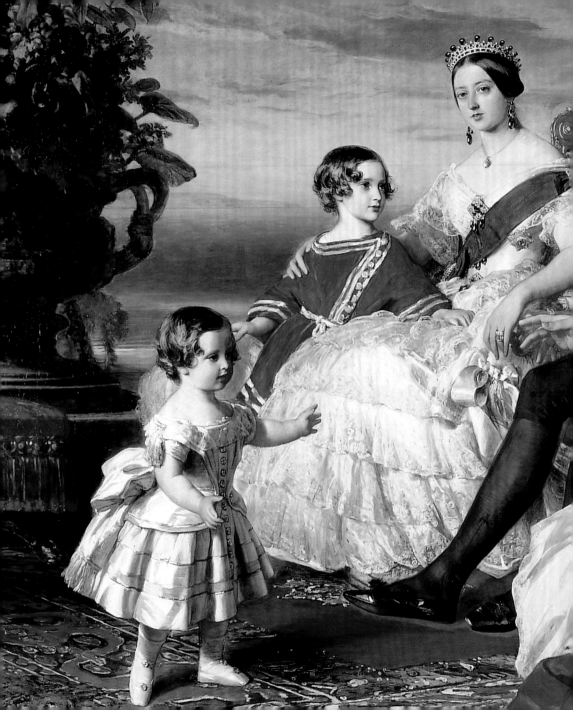

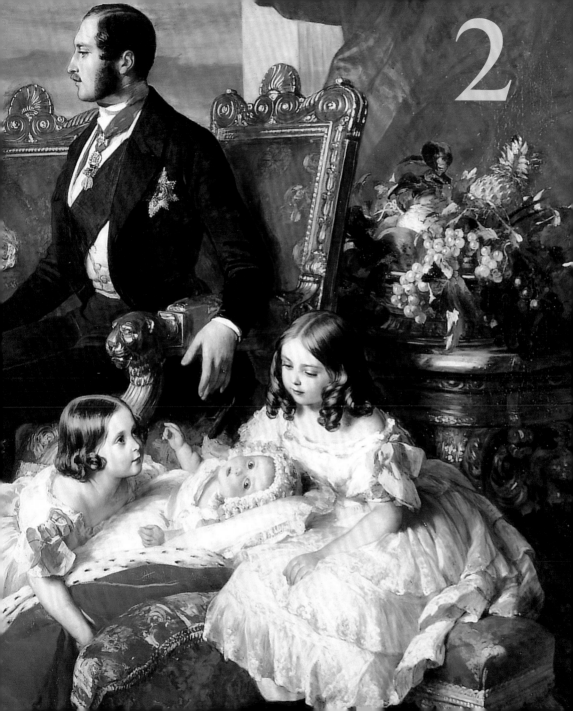

FAMILY

PAGES 38–39:
Franz Xaver
Winterhalter
The Royal Family in 1846
(detail; p.46)

THE BIRTH OF NINE royal children, beginning with Victoria, Princess Royal, on 21 November 1840, and ending with Princess Beatrice on 14 April 1857, provided Queen Victoria and Prince Albert with endless opportunities to commission art. Every milestone in the royal children's development, from the loss of a tooth to the first ride on a horse, was recorded. And as with their collecting as a whole, the Queen and Prince showed a remarkably open-minded approach to the possibilities offered by almost every available art form. With the birth of their first son and the heir to the throne, Albert Edward, Prince of Wales (later King Edward VII), for example, the continuation of the dynasty was not only celebrated in grand oil paintings but in more unusual objects such as a jewel casket made from electro-plated metal, enamel and porcelain. New additions to the family prompted the commissioning of exceptionally crafted pieces of furniture, as well as the arrival of lavish gifts from the royal houses of Europe. But the greatest pleasure was often occasioned by simpler items in the design of which the Queen and Prince had taken a personal hand. The Prince had a particular talent for delighting the Queen with personal items of jewellery that over the years could be added to by a new portrait or another lock of baby's hair.

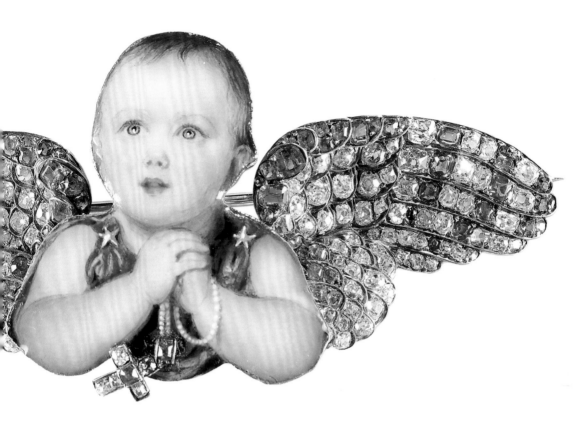

PRINCE ALBERT, designer;
WILLIAM ESSEX (1784–1869),
after SIR WILLIAM ROSS
(1794–1860), miniaturist;
UNKNOWN JEWELLER
Brooch, 1841
Enamel, gold, sapphires,
rubies, emeralds, diamonds
and topazes, 3.5 x 6.8cm
RCIN 4834

Queen Victoria's first child,
also named Victoria, was the
subject of numerous art
commissions including this
enamel, gold and jewelled
brooch. Inspired by a cherub
in a painting by Raphael,
Prince Albert designed the
piece himself as a Christmas
present for the Queen.
'The workmanship & design
are quite exquisite,' she
declared, '& dear Albert was
so pleased at my delight over
it, its having been entirely his
own idea and taste.'

ACTUAL SIZE

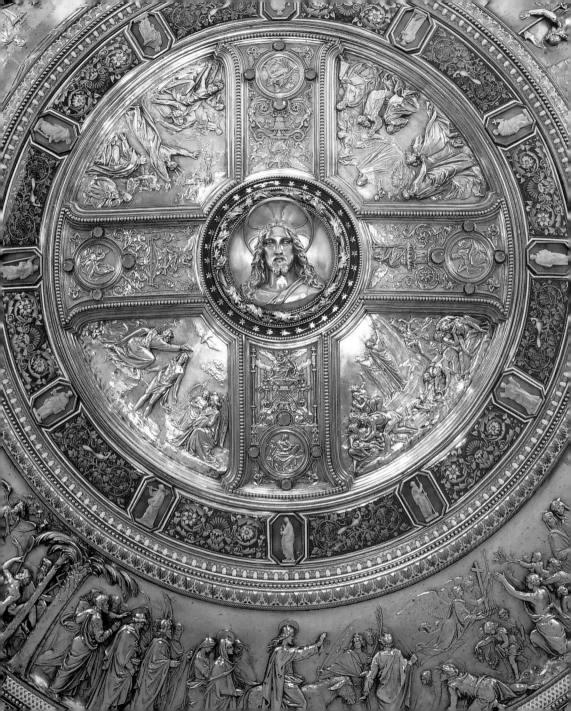

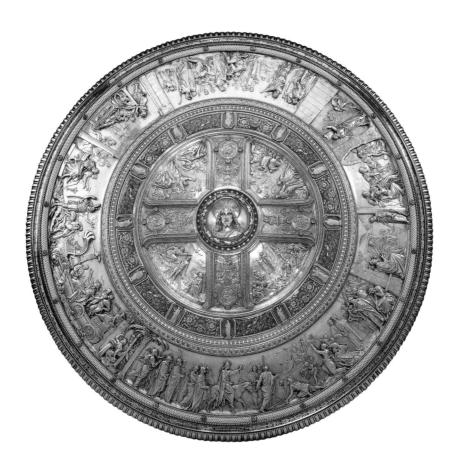

PETER VON CORNELIUS (1783–1867), designer; JOHANN GEORG HOSSAUER (active 1820–1857), goldsmith
The Glaubensschild (Shield of Faith), 1842–47
Silver, gold, enamel, onyx and chrysoprase, diam. 89cm
RCIN 31605

This magnificent shield was given by Frederick William IV, King of Prussia, as a christening gift to Queen Victoria and Prince Albert's first son, Albert Edward, Prince of Wales (who was born on 9 November 1841). The symbolism of the shield, which is covered in biblical scenes and bears the image of Christ the Saviour in its centre, evokes the idea of Christianity as a form of protective armour. It also

acknowledges that, as future king, Albert Edward (later King Edward VII) would one day assume the role of Defender of the Faith. The exceptional craftsmanship of the piece, which took five years to make, was highly praised by Prince Albert who compared the work to the best efforts of 'the classic Italian masters of the 15th and 16th centuries'. In 1851 it was loaned to the Great Exhibition.

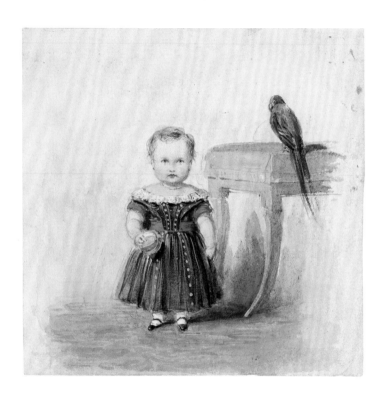

FRANZ XAVER WINTERHALTER
(1805–1873)
*Albert Edward, Prince of Wales
with Prince Alfred*, 1849
Oil on canvas, 63.8 x 45.9cm
RCIN 403121

The German artist Franz
Xaver Winterhalter became
the Queen and Prince's
favourite painter of oil
portraits. He not only
brought drama and colour to
official depictions of the royal
family but, as this portrait of
the two eldest royal sons
shows, he also had a great
talent for capturing the
innocence and charm of
youth. Although the sittings
took place in London, the
boys are depicted as tartan-
clad hunters in a Highland
landscape.

QUEEN VICTORIA (1819–1901)
*The Prince of Wales with a
parrot*, 1843
Watercolour and bodycolour
over pencil, 15 x 15.2cm
RL K62

The nursery life of the royal
children offered Queen
Victoria enormous scope
for her own painting and
drawing. This watercolour of
her first son, Albert Edward,
shows him dressed in skirts,
as was the custom with small
boys, and with a parrot – one
of the family pets.

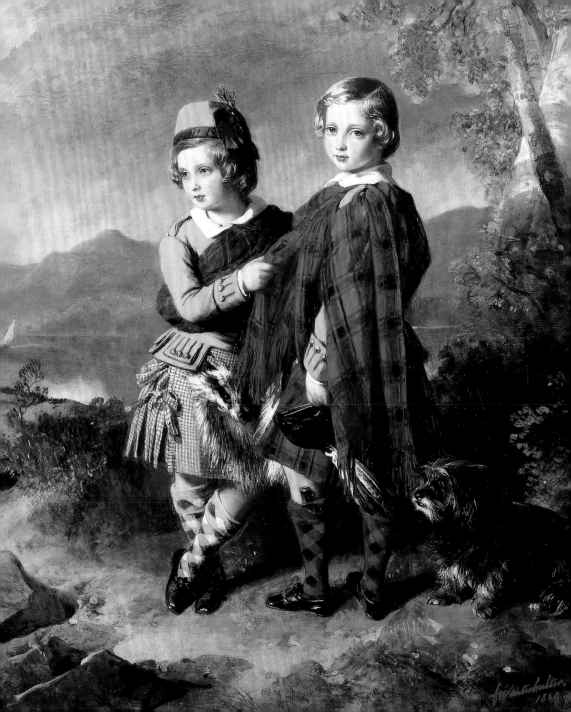

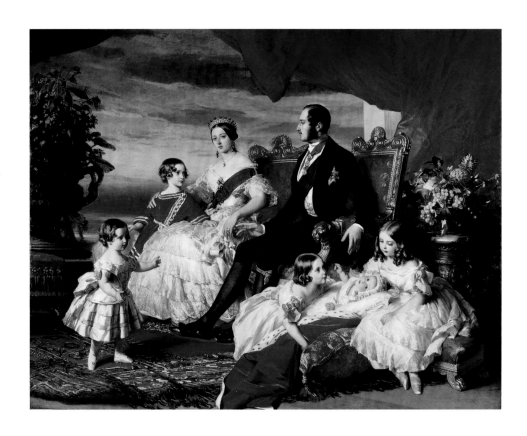

FRANZ XAVER WINTERHALTER
(1805–1873)
The Royal Family in 1846
Oil on canvas,
250.5 x 317.3cm
RCIN 405413

Perhaps the most famous portrait commissioned from Winterhalter, this painting, of 1846, shows Queen Victoria both as Sovereign and mother. Wearing the blue sash and star of the Order of the Garter, the Queen places a protective arm around Albert Edward, the heir to the throne. But the children in the foreground – Prince Alfred in skirts on the left and Princess Alice, baby Helena and the Princess Royal on the right – strike a charmingly informal note. The picture was seen by some 100,000 people when it went on show at St James's Palace and reached many more when engraved for public circulation.

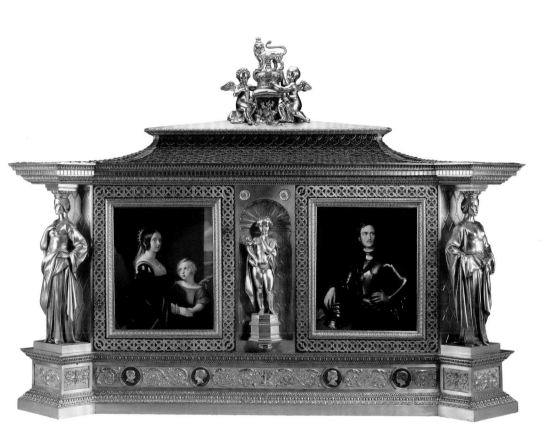

ELKINGTON, MASON & CO. (1842–1861),
manufacturer; LUDWIG GRUNER
(1801–1882), designer
Jewel Cabinet, 1851
Electro-plated white metal, gilt bronze,
enamelled copper, porcelain and oak,
97 X 132 X 81cm
RCIN 1562

One of the more unusual dynastic
statements made by the royal couple, this
jewel casket was designed by the Prince's
artistic adviser, Ludwig Gruner. Perhaps
inspired by Italian Renaissance
reliquaries, the painted porcelain plaque
on the left shows Queen Victoria and the
young Prince of Wales in sixteenth-

century costume, while on the right
Prince Albert appears in shining armour.
The portraits are based on miniatures by
Robert Thorburn, painted in 1845 and
1844. Despite the historical references,
the materials used, including electro-
plated white metal, drew on the very
latest industrial processes.

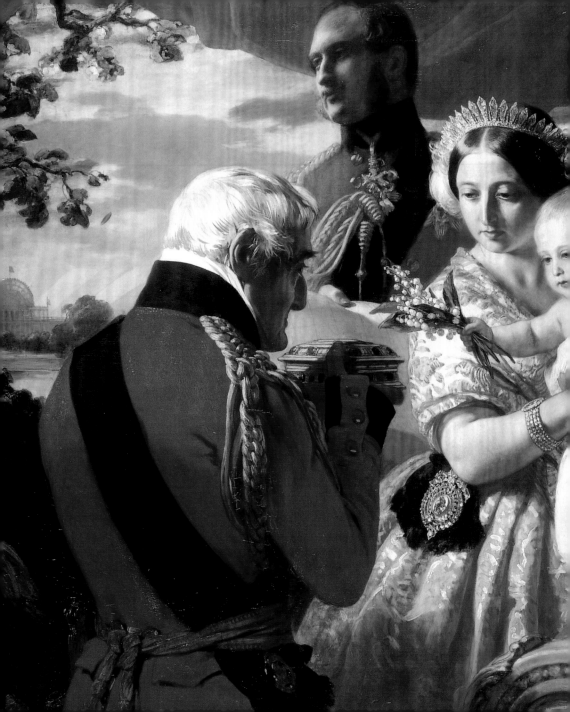

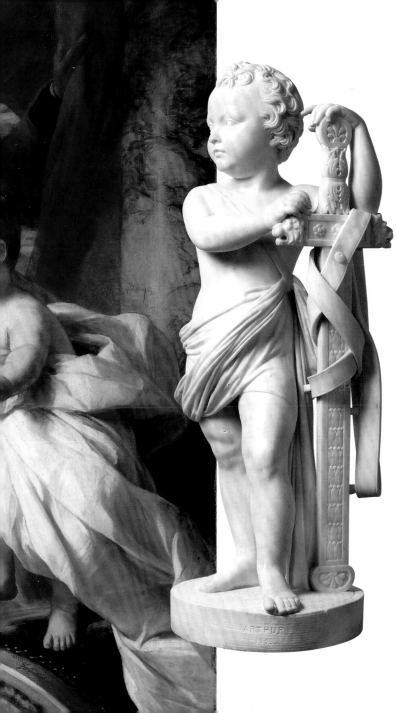

FRANZ XAVER WINTERHALTER
(1805–1873)
The First of May, 1851
Oil on canvas,
106.7 x 129.5cm
RCIN 406995

The Queen's third son
Arthur, born 1 May 1850,
shared a birthday with his
godfather, the Duke of
Wellington. Here the aged
Duke is shown presenting
a casket to the one-year-old
Prince in a way that strongly
recalls images of the Wise
Men before the infant
Jesus. In addition to
commemorating a shared
birthday, the picture also
marked the opening of the
Great Exhibition in the
Crystal Palace, which
appears on the far left.

CARLO, BARON MAROCHETTI
(1805–1867)
Prince Arthur, 1853
Marble, height inc. base
101cm
RCIN 2076

This marble portrait of
Prince Arthur could be seen
as a sequel to Winterhalter's
The First of May (opposite).
Here, the Duke of
Wellington is symbolically
represented by the sword
held by the three-year-old
Prince. The Duke had died
in 1852, and the Queen came
to see her favourite son as
the inheritor of the Duke's
military valour.

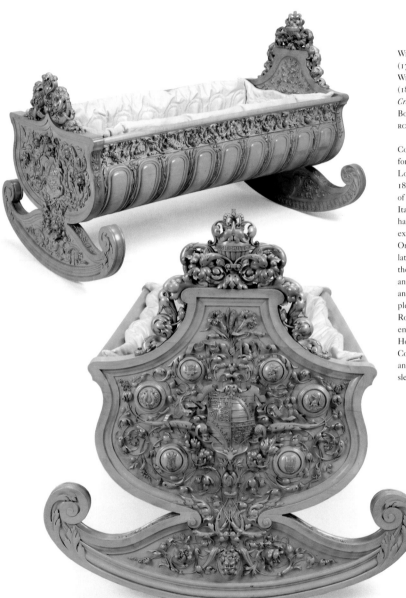

WILLIAM GIBBS ROGERS
(1792–1875), carver;
WILLIAM HARRY ROGERS
(1825–1873), designer
Cradle, 1850
Boxwood, 63 x 91 x 62cm
RCIN 1516

Commissioned by the Queen
for the infant Princess
Louise, born on 18 March
1848, the shape and design
of this cradle belong to the
Italian Renaissance and may
have been inspired by
examples seen in paintings.
On its delivery two years
later the Queen described
the cradle as 'finer than
anything of the kind, either
antique or modern,' and was
pleased to note how well
Rogers had interwoven the
emblems from the Royal
Houses of England and Saxe-
Coburg along with flowers
and figures associated with
sleep.

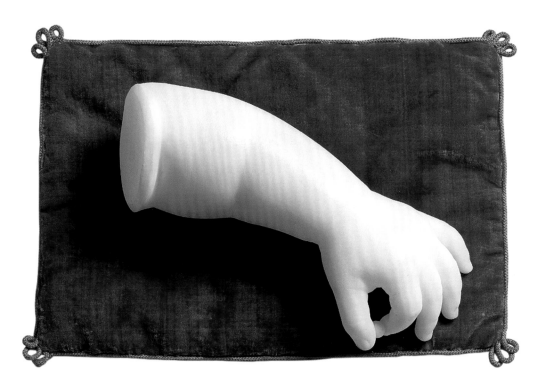

MARY THORNYCROFT
(1809–1895)
*Left arm and hand of Princess
Louise*, 1848
Marble, length 16cm
RCIN 34578

One of the more unusual
ways the Queen kept
souvenirs of her children was
by commissioning marble
facsimiles of their infant
forearms and feet. Each
carving was based on a
plaster cast made from
moulds taken while the child
was asleep. The sculptor,
Mary Thornycroft, worked
for the royal couple for many
years and excelled in her
depictions of their children.

ENGLISH
Brooch, 1847
Gold, enamel and tooth,
2.7 x 2.1cm
RCIN 13517

No event in the royal children's
lives was deemed unworthy
of commemoration. This tiny
gold and enamel brooch in the
form of a thistle has as its
flower the first milk tooth lost
by Victoria, the Princess Royal.
An inscription on the reverse
states the tooth was pulled by
Prince Albert at Ardverikie
(Loch Laggan), on 13
September 1843.

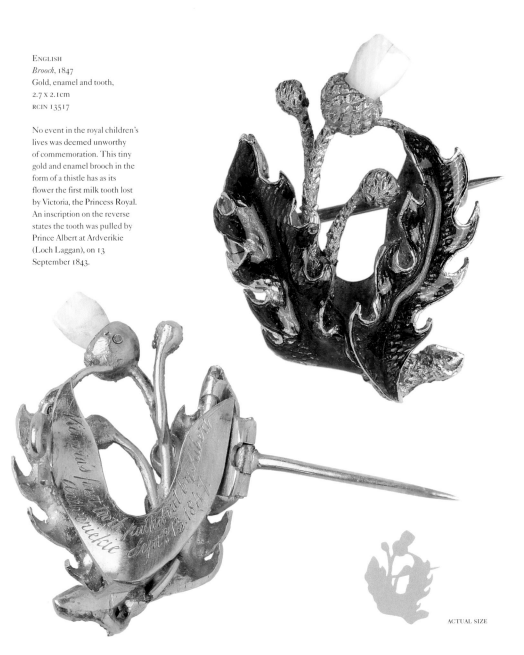

ACTUAL SIZE

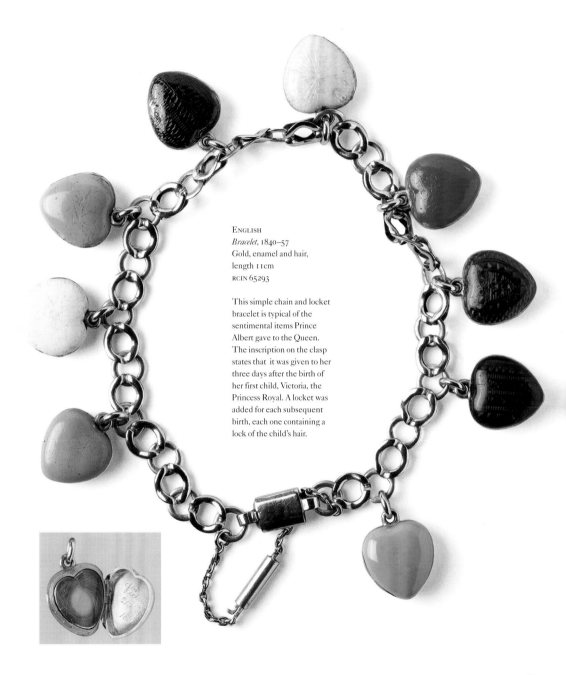

ENGLISH
Bracelet, 1840–57
Gold, enamel and hair,
length 11cm
RCIN 65293

This simple chain and locket
bracelet is typical of the
sentimental items Prince
Albert gave to the Queen.
The inscription on the clasp
states that it was given to her
three days after the birth of
her first child, Victoria, the
Princess Royal. A locket was
added for each subsequent
birth, each one containing a
lock of the child's hair.

JAMES ROBERTS (c.1800–1867)
Queen Victoria's Birthday Table
at Osborne, 1861
Watercolour and bodycolour,
18.3 x 24.5cm
RL 19874

The delight in giving gifts
at birthdays, Christmas and
on wedding anniversaries
was an activity shared by the
whole royal family. Presents
would be displayed on and
around a special table.
This watercolour records
the elaborate table and
decorations set out for
the Queen's birthday,
24 May 1861.

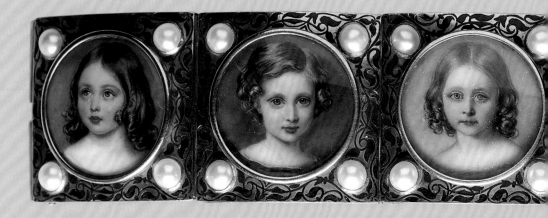

UNKNOWN JEWELLER;
WILLIAM ESSEX (1784–1869),
after SIR WILLIAM ROSS
(1794–1860), miniaturist
Gold bracelet, 1845, *set with six
miniatures: Victoria, Princess
Royal*, 1845; *Albert Edward,
Prince of Wales*, 1846; *Princess
Alice*, 1847; *Prince Alfred*, 1848;
Princess Helena, 1850; *Princess
Louise*, 1854

UNKNOWN JEWELLER;
WILLIAM ESSEX (1784–1869)
and WILLIAM CHARLES BELL
(1831–1904), miniaturists
Gold bracelet, 1854, *set with
three miniatures: Prince Arthur,
1854; Prince Leopold*, 1857;
Princess Beatrice, 1861
Gold and blue *champlevé*
enamel, pearls, enamel
and hair, each miniature
diam. 2.5cm
RCIN 4797 and RCIN 4796

Queen Victoria's liking
for miniature portraits was
served particularly well
by the bracelet (top)
commissioned by Prince
Albert. Presented on her
twenty-sixth birthday in
1845, with the miniature of
her eldest child, Victoria, the
bracelet was subsequently
added to with portraits of five
further royal children as they
reached the age of four. A
second bracelet, including
the portraits of the three
royal children born in or after
1850, was created using the
same enamel and pearl
setting. The three later
portraits were mounted
on a velvet band.

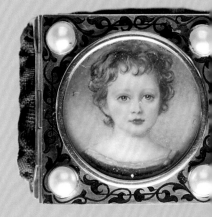

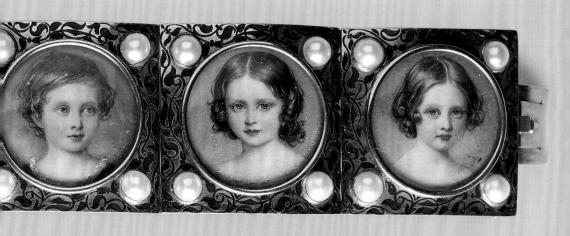

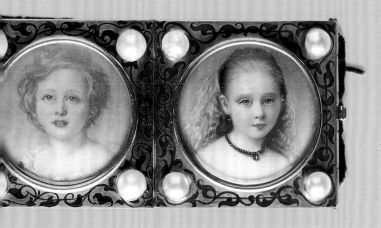

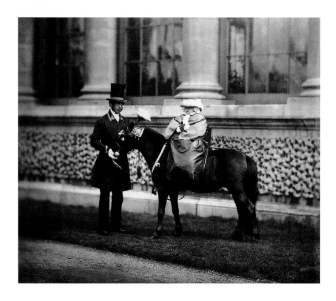

RIGHT:
SIR WILLIAM ROSS
(1794–1860)
Victoria, Princess Royal, 1850
Watercolour on ivory
mounted on zinc,
23.8 x 18.3cm
RCIN 421115

The royal children often adopted fancy dress and performed in theatricals for their parents (see *Entertainment*). So this image, showing the Princess Royal in Turkish dress, may record such an event. Painted by Ross in iridescent colours, the work was exhibited at the Royal Academy in 1851 where it was hailed as 'one of the painter's very best productions'.

ABOVE:
LEONIDA CALDESI
(1823–1891)
Princess Beatrice taking her first ride on her second birthday, 14 April 1859
Albumen print on paper,
13.4 x 16cm
RCIN 2900172

Queen Victoria often commissioned Leonida Caldesi – whom she described as 'a very clever man' – to take portraits of the royal children. This image of the Queen's youngest child, Princess Beatrice, was taken at Buckingham Palace on the occasion of her second birthday. After the formalities of having her portrait taken were over, the Queen noted that Beatrice and her little friends 'ran about in the Lower Corridor, after their supper and had great fun together'.

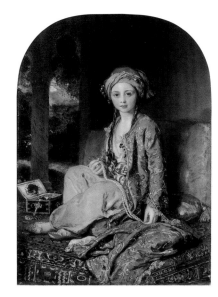

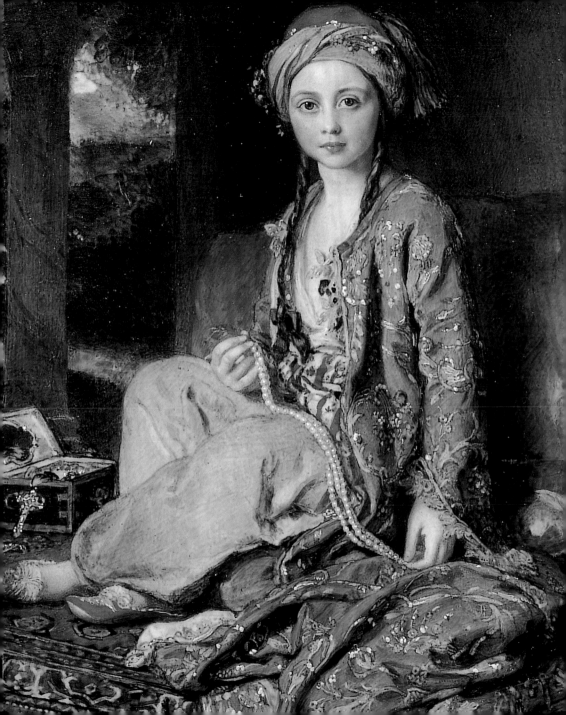

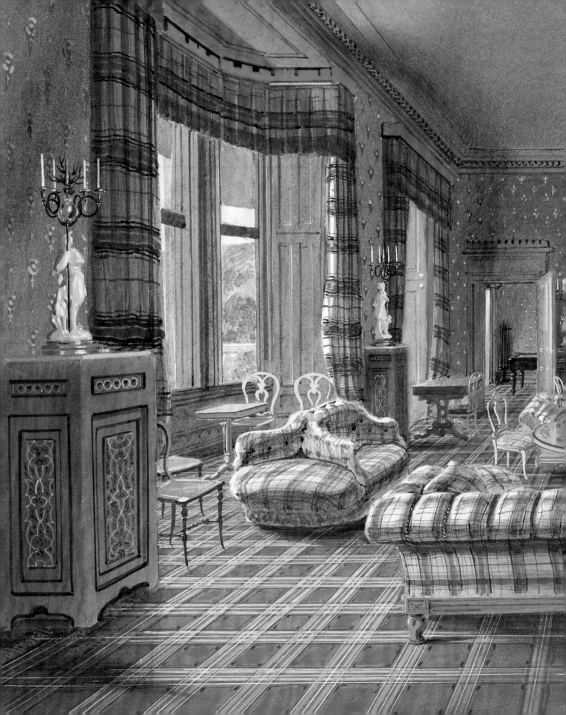

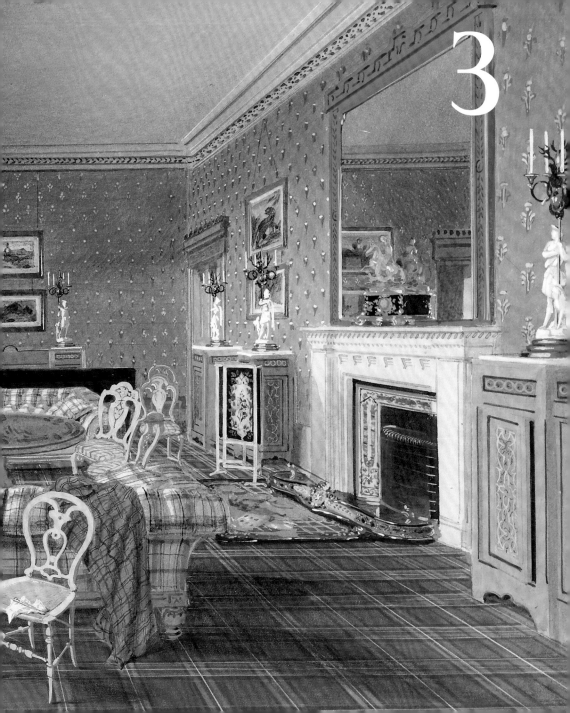

HOME

PAGES 60–61:
JAMES ROBERTS
*Balmoral Castle: the Drawing
Room*, 1857 (detail; p.82)

THE PLACES THAT Queen Victoria, Prince Albert and their growing family regarded as homes – Buckingham Palace and Windsor Castle, Osborne House and Balmoral Castle – were the focus of some of their greatest campaigns as patrons of the arts. Their belief in promoting what they saw as the very best in modern design and manufacture, as well as their enthusiasm for taking a personal hand in each commission, meant the Queen and Prince attended to almost every aspect of the building, decoration and furnishing of these residences. There was much for them to do. Buckingham Palace, which before Queen Victoria's accession had lain incomplete and empty for many years, needed enlarging and thorough redecoration – a scheme for which Prince Albert and Ludwig Gruner revived the luminous colour schemes of Raphael. At Windsor Castle, a number of modernising projects that included the building of a Royal Dairy were personally overseen by the Prince, while the royal couple both took a hand in the ambitious project of designing, building and furnishing Osborne House on the Isle of Wight. However, it was their home at the other end of the kingdom, Balmoral Castle, in Scotland, that gave rise to some of their most individual commissions. From designing their own tartans, to commissioning candelabra supported by the figures of kilted highlanders, the outdoor pursuits, landscape and colourful costume of Scotland were cherished by the royal couple and constantly remembered, even when they were far away.

Buckingham Palace

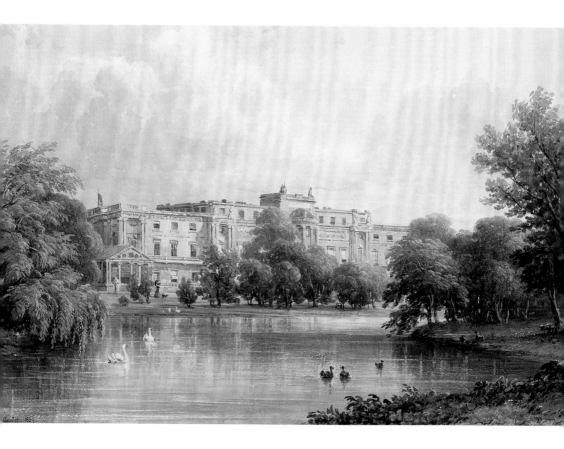

This watercolour shows the west front of Buckingham Palace seen from the garden. The Palace had been built for the Queen's uncle, George IV, but it remained incomplete at his death in 1830 and progressed little under his brother and successor, William IV. After Queen Victoria acceded to the throne on 20 June 1837, more than three hundred workmen had to be employed to make it habitable for her arrival there on 14 July.

In 1845 Queen Victoria complained of 'the total want of accommodation for our little family' at Buckingham Palace. New building work took place and in addition to suites of rooms for the royal children, the State Rooms were extended to include this magnificent ballroom where up to 2,000 guests could be entertained. The decorations, overseen by Ludwig Gruner, were inspired by Italian Renaissance designs in the antique style.

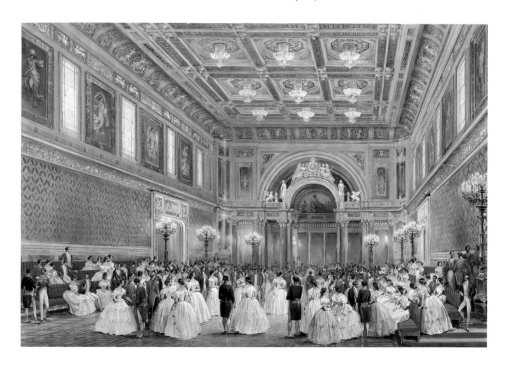

This watercolour by the French artist Eugène Lami evokes the glittering entertainments held at Buckingham Palace, and also records one of the major new decorative schemes there. While the Queen oversaw the arrangement of the full-length portraits of her immediate forebears, seen here lining the top of the stairs, the Prince, through Ludwig Gruner, supervised the painting of the walls in compartments of bright colours.

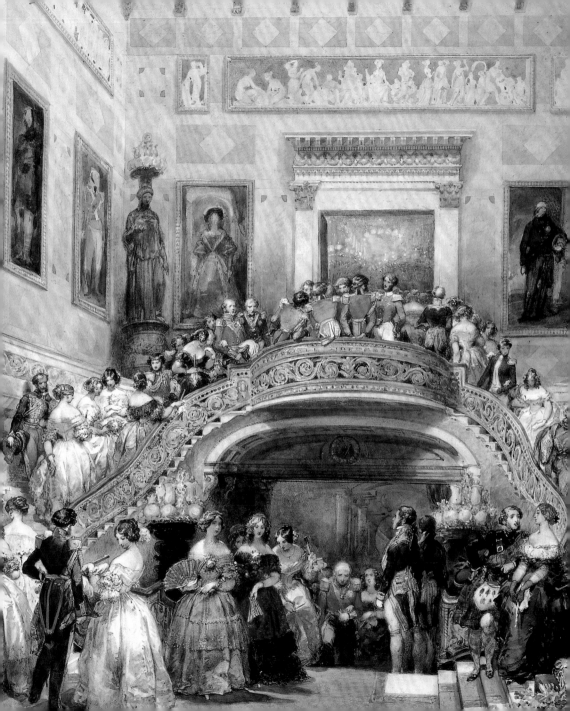

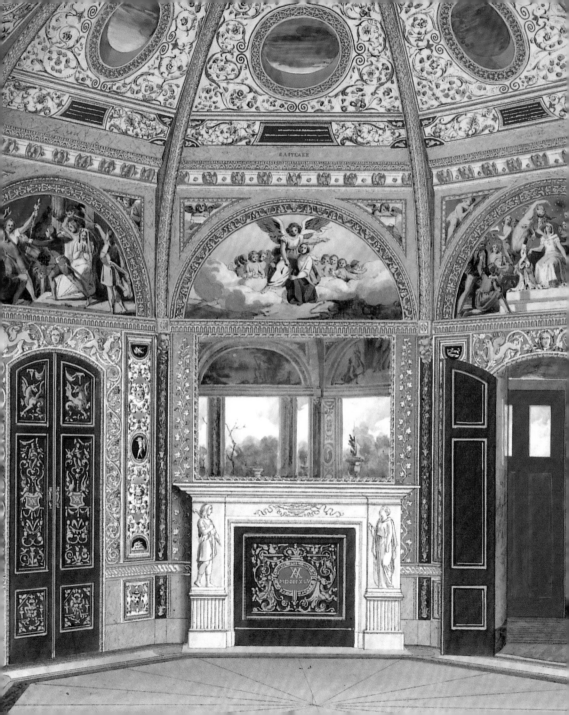

LUDWIG GRUNER
(1801–1882) and ANNA
BROWNELL JAMESON
(1794–1860)
The Comus Room (left) and
the Walter Scott Room (right)
from *The Decorations of the
Garden Pavilion in the grounds
of Buckingham Palace*,
London: John Murray, 1845
Coloured engraving on
paper, 44.5 x 35.4cm
RCIN 708005

In the early 1840s the
building and decoration of a
small cottage or pavilion in
the garden of Buckingham
Palace, initially intended as
'a place of Refuge', turned
into a major project. The
Prince saw it as a step
towards the introduction of
the Italian technique of
fresco to Britain, and
commissioned British artists
to decorate rooms dedicated
to the works of native
authors, such as *Comus* by
John Milton. The Pavilion
was demolished in the 1930s.

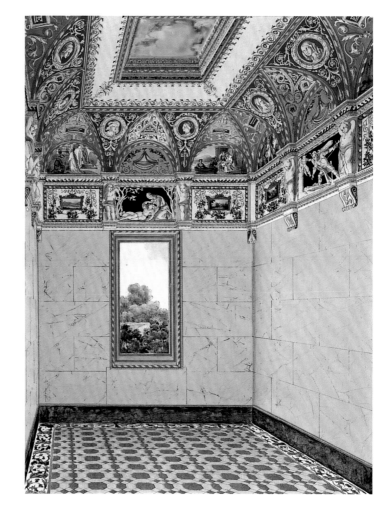

Osborne

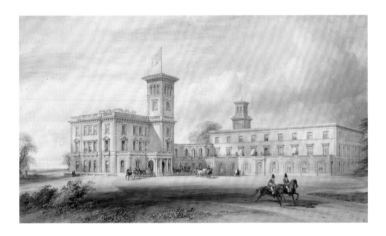

Thomas Cubitt (1788–1855)
Osborne House: design for the entrance front, 1845
Watercolour and bodycolour over graphite, 51 x 85.2cm
RL 19838A

In 1843 the Osborne estate on the Isle of Wight was purchased as a private retreat for the royal family. Prince Albert, working as his own architect with the contractor Thomas Cubitt, designed a new house in the Italianate style. Work went ahead at a tremendous pace. In September 1846 the Queen was able to write, 'It seems to me like a dream to be here now in our house, of which we laid the first stone only 15 months ago!'

Franz Xaver Winterhalter (1805–1873)
Queen Victoria with Prince Arthur, 1850
Oil on canvas, 59.5 x 75.1cm
RCIN 405963

The Italianate style of Osborne House, with its terraces overlooking the Solent, gave it the character of a Mediterranean villa – a feeling strongly emphasised in this portrait of the Queen with her third and favourite son, Prince Arthur.

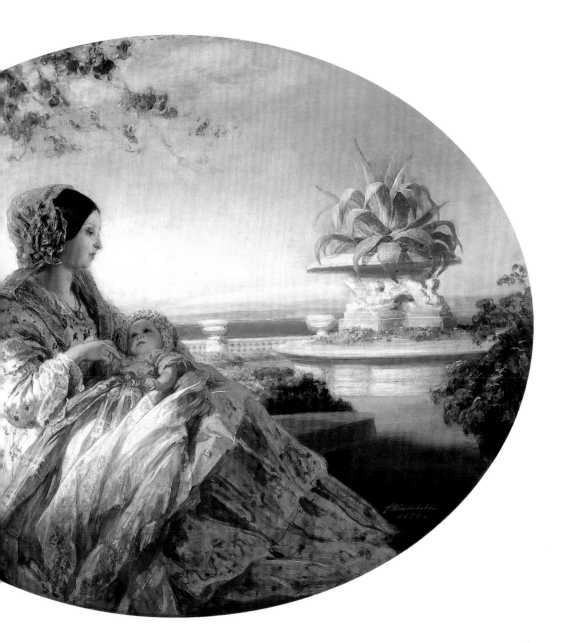

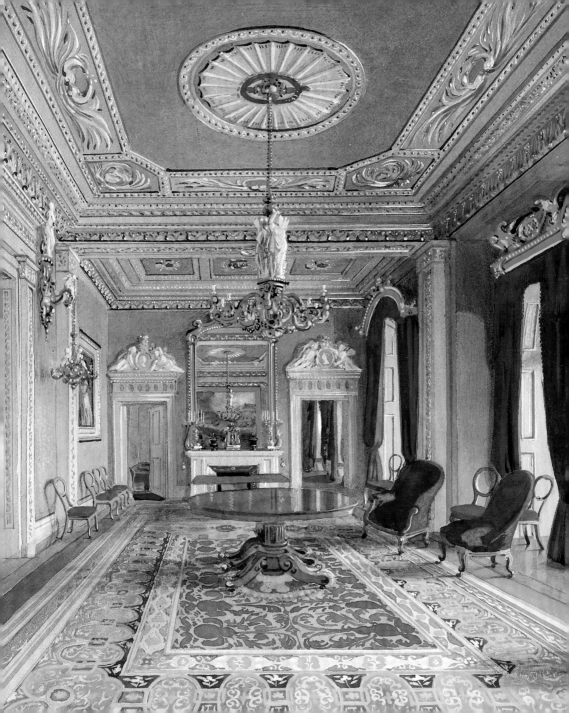

As Osborne House was a private residence, the personal tastes of the royal couple were given full expression there. The Council Room, intended for use by the Privy Council while the Queen was in residence, shows the intense and bright colour scheme devised by Ludwig Gruner and Prince Albert. Above the far doorways are plaster relief portraits of the Queen and Prince, while the patterned carpet contains their cipher.

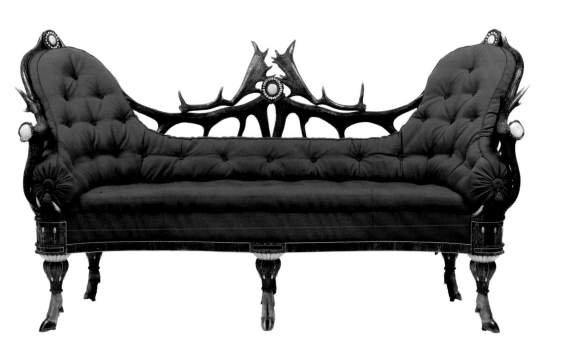

A taste for furniture constructed using stags' horns, hoofs and teeth was common among the royal and aristocratic houses of central Europe. Made in Coburg, this sofa was part of a set the royal couple assembled for the Horn Room at Osborne. It was probably a gift to Prince Albert from his elder brother, Duke Ernest II of Saxe-Coburg and Gotha.

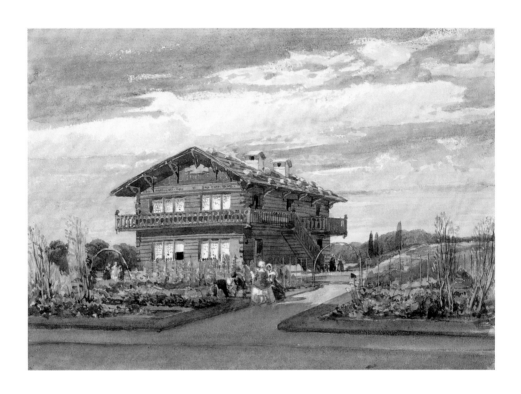

William Leighton Leitch (1804–1883)
Osborne: the Swiss Cottage, 1855
Watercolour,
19.7 x 27.8cm
RL 19867

Remembering the Swiss Cottage at the Rosenau, where he and his brother had played as children, Prince Albert had a full-scale Swiss chalet constructed in the grounds at Osborne. The Prince hoped his children would use the cottage to learn the basics of housekeeping, collecting, gardening and entertaining. The elaborately carved writing table (opposite), decorated with scenes of Swiss sport and agriculture, was bought to furnish the cottage.

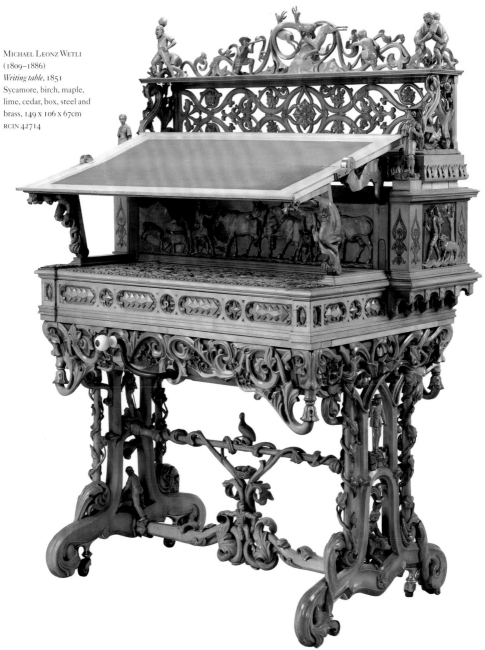

MICHAEL LEONZ WETLI
(1809–1886)
Writing table, 1851
Sycamore, birch, maple,
lime, cedar, box, steel and
brass, 149 x 106 x 67cm
RCIN 42714

Windsor

Sir Edwin Landseer
(1803–1873)
*Windsor Castle in Modern
Times; Queen Victoria, Prince
Albert and Victoria, Princess
Royal*, 1840–43
Oil on canvas,
113.3 x 144.5cm
RCIN 406903

Soon after his marriage to the
Queen, Prince Albert was
appointed Ranger of Windsor
Great Park. Here he appears
in the Green Drawing Room
at the Castle, having
returned from a day's shoot,
with the 'bag' laid out for the
admiration of the Queen. As
this picture took a number of
years to complete, Landseer
was able to add the figure of
the royal couple's first child,
Victoria, Princess Royal, on
the left.

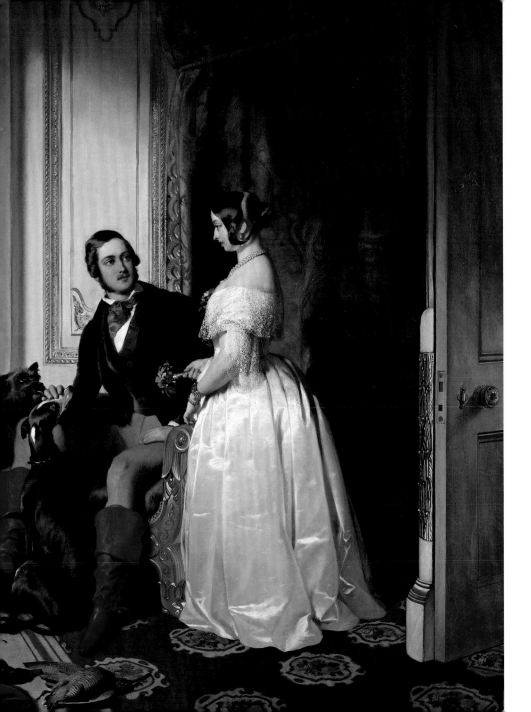

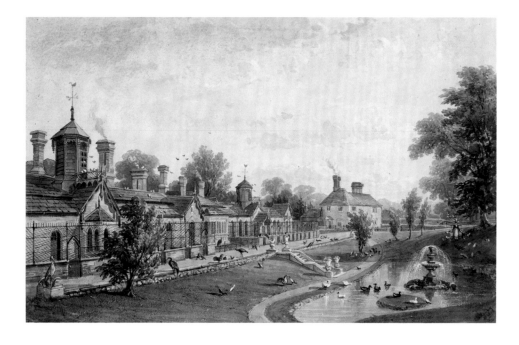

Prince Albert's improvements in the
Home Park at Windsor included a new
poultry farm and aviary, and a state-of-
the-art dairy, including a creamery
entirely lined in ceramic tiles. For these
the Prince commissioned the Stoke-on-
Trent firm of Minton to use their most
recently developed decorative processes.
This included an entirely new form of
glaze, which was used on the fountains
that supplied water to run beneath the
creamery tables to keep them cool.

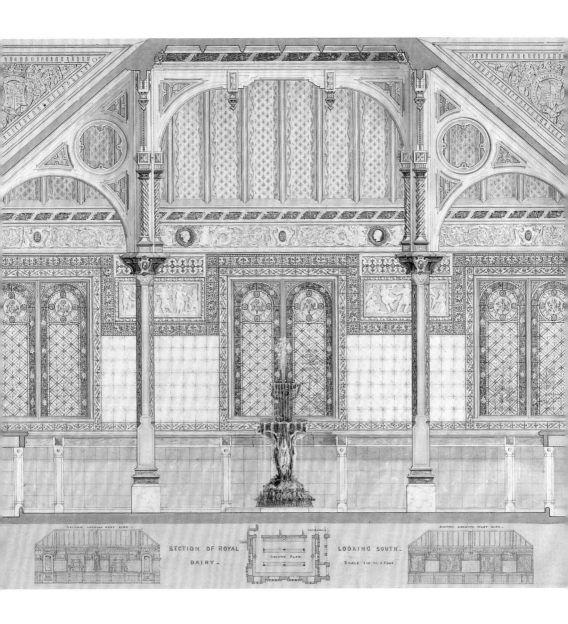

SECTION OF ROYAL DAIRY. LOOKING SOUTH.

GROUND PLAN. SCALE 1 IN. TO 1 FOOT.

Balmoral

RIGHT:
JAMES GILES (1801–1870)
*Balmoral: design for the
north-west front of the new
castle*, 1853
Watercolour and bodycolour,
50.5 x 70cm
RL 21524

The Queen and Prince
Albert made their first visit to
Scotland in 1842. Six years
later they purchased the
lease of Balmoral, a Deeside
estate, and set about
rebuilding the castle. This
watercolour shows one of the
designs. Completed in 1856,
the Queen wrote proudly
that 'all has become my
dearest Albert's *own* creation,
own work, own building, own
laying out … his great taste,
and the impress of his dear
hand, have been stamped
everywhere.'

OVERLEAF:
CARL HAAG (1820–1915)
*Morning in the Highlands:
the royal family ascending
Lochnagar*, 1853
Watercolour, bodycolour
and scraping out,
77 x 133.6cm
RL 22032

Painted by the Bavarian-
born watercolourist, Carl
Haag, this picture shows the
Queen and Prince ascending
Lochnagar, on the Balmoral
estate, accompanied by
the royal children, their
governess Miss Bulteel and
a number of gillies. The
snaking procession and
the sweep of the Queen's
riding habit create a sense
of dynamism, while the
luminous colouring and
unusually large size (the
equivalent of many oil
paintings) singled it out
for particular praise when
it went on public display
in 1854.

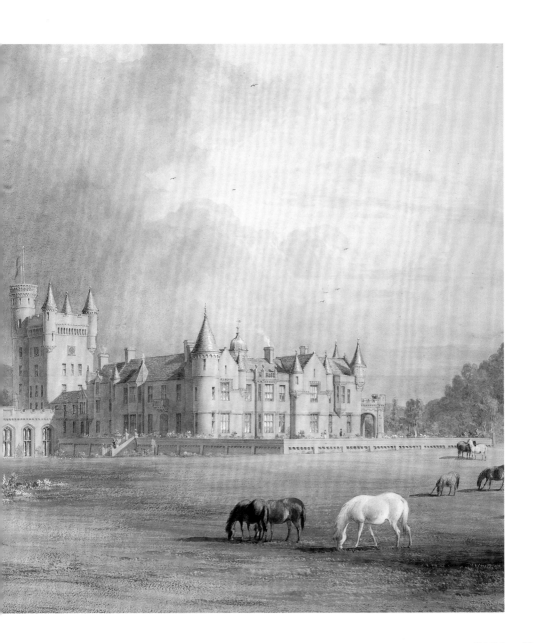

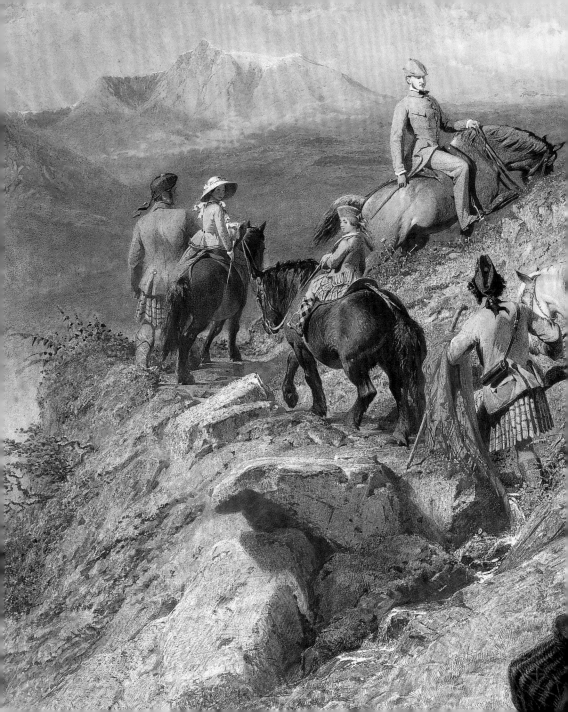

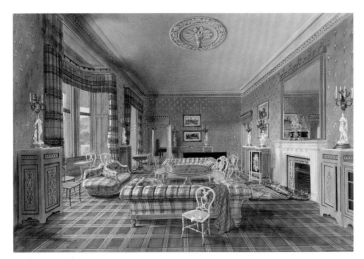

JAMES ROBERTS (c.1800–1867)
*Balmoral Castle: the Drawing
Room*, 1857
Watercolour and bodycolour
over pencil, 26 x 38.3cm
RL 19477

HOLLAND & SONS
(after 1843–1942)
Cabinet, 1855
Satinwood, mahogany,
marble and glass,
126 x 199 x 58cm
RCIN 13109.1

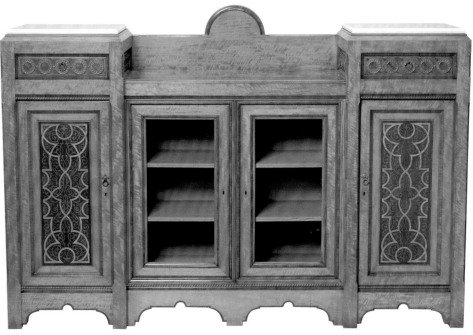

HERBERT MINTON & CO.
and R.W. WINFIELD & CO.,
manufacturers;
SIR EDWIN LANDSEER
(1803–1873), designer
Candelabra, 1854
Unglazed porcelain (Parian
ware), copper alloy, plated
with silver and partly
patinated, 94 x 38 x 38cm
RCIN 12143.1

The light and bright interiors
at Balmoral made a strong
contrast with the baronial
style popular among the
Queen and Prince Albert's
contemporaries. A view of
the Castle's Drawing Room
(left), for example, shows
a blue thistle-patterned
wallpaper contrasted with
different-coloured tartans
in the upholstery, curtains
and carpet. A suite of pale
satinwood furniture,
including the cabinet (left),
lines the walls, while
standing on these can be
seen a set of candelabra
designed by Landseer and
manufactured by two leading
firms from Birmingham and
Stoke-on-Trent. The
candlestands, including
the two examples on this
page, are supported by
kilted Highlanders made
by Minton from unglazed
porcelain.

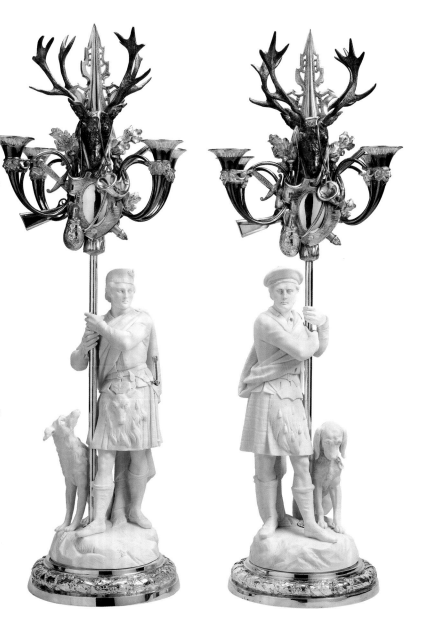

SIR EDWIN LANDSEER (1803–1873)
The Sanctuary, 1842
Oil on canvas,
61.3 x 152.7cm
RCIN 403195

This work, depicting an exhausted stag finding sanctuary from its pursuers on an island in Loch Maree, was first owned by Landseer's chief patron, William Wells. On seeing the picture at the Royal Academy in 1842, Queen Victoria asked Wells to sell it to her – a request he was unable to refuse. Delighted with her acquisition, the Queen presented the picture to her husband on his twenty-third birthday.

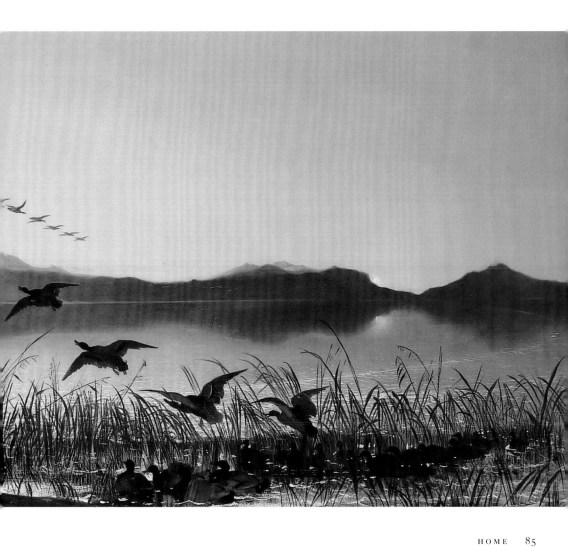

ENTERTAINMENT

FROM THE OUTSET music, theatre and entertainment formed an essential part of the Queen and Prince Albert's life together. Music had done much to spark their romance in the early days. And the fact that both had real talent as musicians – the Prince as an organist, composer and singer, and the Queen as a pianist and singer – meant their continued interest in music was a serious one. The German composer Mendelssohn became a personal friend, and arranged some of his compositions for the couple to play together. Pianos were to be found in all the royal residences; there was even one on the Royal Yacht, and the Prince's interest and proficiency in organ-playing ensured that fine instruments were installed in the new Ballroom at Buckingham Palace as well as in his private rooms. The Queen's childhood love of opera and the theatre continued unabated. She went to see her favourite pieces time and again, and performers from leading London theatres were engaged for Windsor Castle and Buckingham Palace. As with the royal couple's patronage of the visual arts, these private entertainments did much to support home-grown talent, although visiting artists such as the 'Swedish Nightingale', Jenny Lind, were also invited to give private recitals. Of the domestic performances, theatricals involving the royal children and members of the court were especially enjoyed. As all the royal family loved dressing up, and the Queen particularly enjoyed dancing, the royal couple gave a series of spectacular fancy-dress balls at Buckingham Palace.

SIR EDWIN LANDSEER
(1803–1873)
Queen Victoria and Prince Albert at the Bal Costumé of 12 May 1842, 1842–6
Oil on canvas, 143 x 111.6cm
RCIN 404540

For their first costume ball, held at Buckingham Palace in 1842, Prince Albert and Queen Victoria dressed as King Edward III and his consort Queen Philippa of Hainault. They received their guests – over 2,000 were invited – in the Throne Room, which had been decked out with a gothic canopy decorated with a purple velvet cloth of state. The royal couple's lavish costumes were designed to give maximum employment to the silk weavers of Spitalfields in London.

PAGES 86–7:
FELIX MENDELSSOHN BARTHOLDY
Lied ohne Worte für das Piano vierhändig, 1847
(detail; pp.98–9)

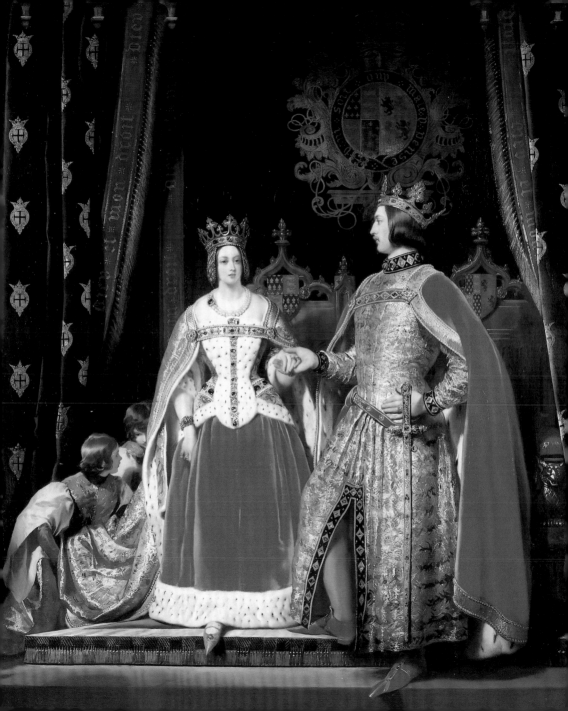

UNKNOWN MAKER and
EUGENE LAMI (1800–1890),
designer
*Queen Victoria's costume
for the Stuart Ball*, 1851
Moiré silk, brocade, lace,
silk braid and silk ribbon, silk
velvet ribbon, faux pearls,
silver fringe and hangers
RCIN 74860

OPPOSITE:
EUGENE LAMI (1800–1890)
*The Stuart Ball at Buckingham
Palace, 13 June 1851*, 1851
(detail)
Watercolour and bodycolour
over pencil, 30.6 x 45.2cm
RL 19904

The French artist Eugène
Lami designed this elaborate
costume of *moiré* silk, lace,
ribbons and silver braid for
Queen Victoria to wear at
the Stuart Ball held at
Buckingham Palace in
1851. Lami also recorded
the event in the water-
colour commissioned
by the Queen for her
Souvenir Album.
The figures of the
Queen and her
husband can be
seen on the right.
Both wear the
blue sash of the
Order of the
Garter, while the
Prince wears
matching blue
stockings and a
long wig.

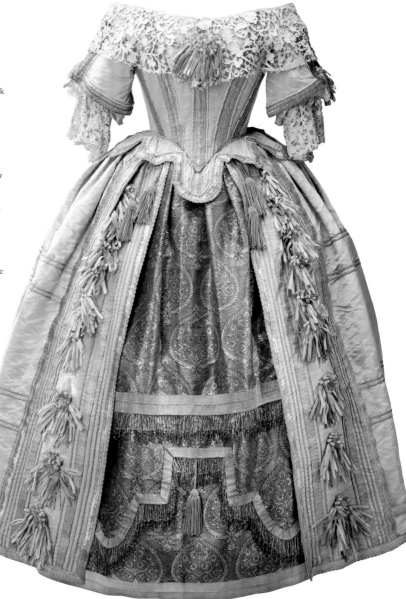

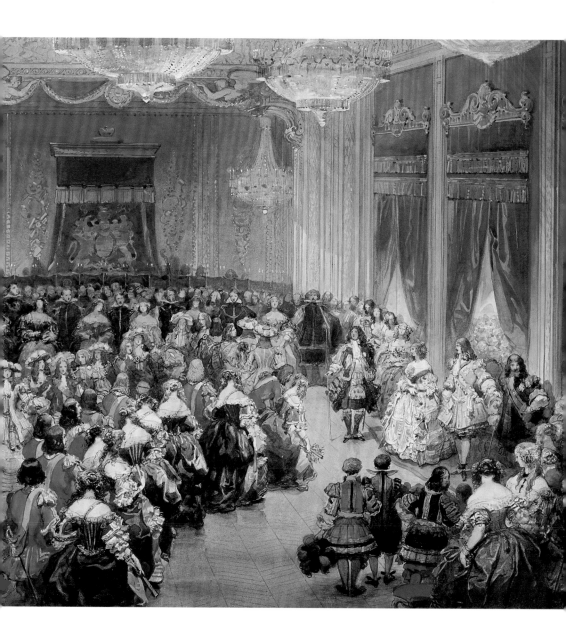

RIGHT:
ROGER FENTON (1819–1869)
The Royal Children: Concluding Tableau of The Seasons, 1854
Salted paper print,
16.8 x 16.9cm (image)
RCIN 2900037

The photograph opposite strikes a vivid contrast with the image of the two Princesses in fancy dress on the left. Here Roger Fenton shows the royal children in the concluding tableau of their performance of the 'Seasons', based on the eighteenth-century poem by James Thomson. Seated (from left) are Princess Alice as Spring, the sleeping Prince Arthur and the Princess Royal as Summer, Prince Alfred in panther skin and vine-leaves as Autumn, with the well wrapped-up Princess Louise and the Prince of Wales in beard and cloak as Winter. Standing at the back is Princess Helena who concluded each performance by pronouncing a blessing on the Queen and Prince in the name of all the Seasons.

FRANZ XAVER WINTERHALTER (1805–1873)
Victoria, Princess Royal and Princess Alice in eighteenth-century costume, 1850
Watercolour over slight indications in pencil,
28.8 x 23.8cm
RL 13335

On 24 May 1850 the nine-year-old Princess Royal (right) and the seven-year-old Princess Alice performed a minuet in honour of their mother's birthday. Both were dressed in costumes of the 1740s, echoing a fancy-dress ball held in 1845 at which the Queen and Prince had danced the same steps. This watercolour by Winterhalter was commissioned to record the event and was placed in the Queen's Portrait Album.

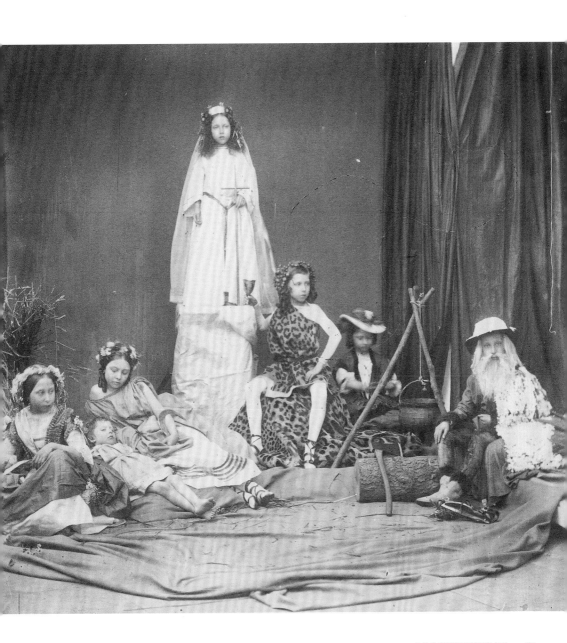

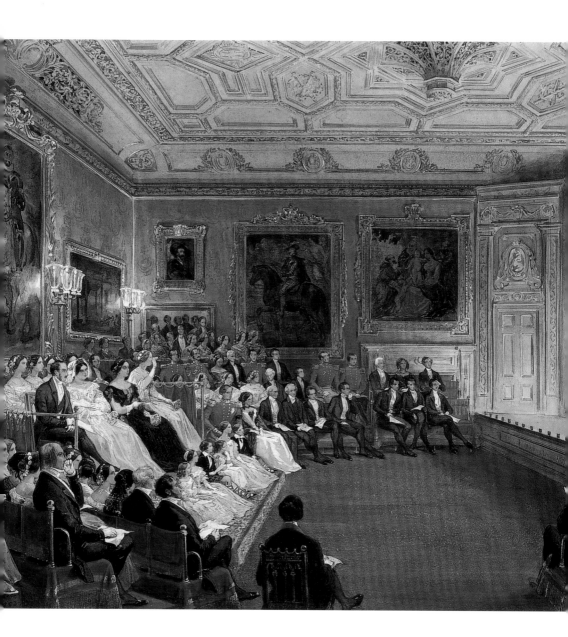

LOUIS HAGHE (1806–1885)
A Performance of Macbeth *in the Rubens Room, Windsor Castle, 4 February 1853*, 1853
Watercolour and bodycolour with gum arabic over pencil, 33.4 x 48.2cm
RL 19794

Complaints in the press concerning the Queen's obvious delight in foreign opera and theatre resulted in the institution of annual theatricals performed by the British company of the actor Charles Kean. This depiction of the company's *Macbeth* in the Rubens Room at Windsor Castle shows the Queen and Prince seated on the left, with the royal children on the floor before them.

EDWARD CORBOULD (1815–1905)
The Coronation Scene from Meyerbeer's Le Prophète, 1850
Watercolour, 101 x 127cm
RL 21594

The opera *Le Prophète*, a complex tale set in sixteenth-century Germany, was one of Queen Victoria's favourites. She was particularly thrilled by the scene depicted above in which 'The Prophet', John of Leyden (centre), is recognised by his mother (left). Having posed as a Heavenly Messenger, John of Leyden challenges his followers to kill him if they believe the woman's claims. The mother, fearing for her son's life, declares she has been mistaken and is dragged off to prison.

PRINCE ALBERT
Compositions, 1847–53
Manuscript, 23.8 x 34cm
RCIN 1077784

This page comes from one of a pair of volumes gathering songs composed by Prince Albert. Although he modestly claimed that his reason for gaining artistic or musical expertise was not 'with a view of doing anything worth looking at or hearing, but simply to enable me to judge and appreciate the works of others,' he was a talented composer, some of whose best works have been described as reminiscent of Schubert.

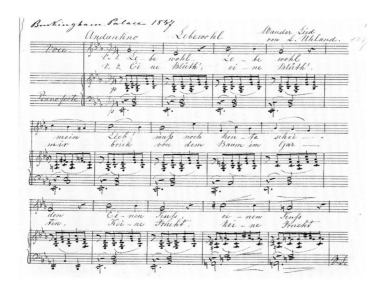

S. & P. ERARD (active 1780–1960)
Grand piano, 1856
Gilded, painted and varnished mahogany, satinwood, pine, steel, brass, gilt bronze, leather, ebony and ivory, 95.7 x 243.8 x 142.2cm
RCIN 2426

As keen players, the Queen and Prince installed pianos in the private apartments of all their residences. But this elaborately decorated instrument by Erard was intended as a showpiece for the State Rooms at Buckingham Palace. The gilded case is decorated in the French early eighteenth-century style with cherubs and *singeries* – comical scenes involving monkeys playing musical instruments and making mischief.

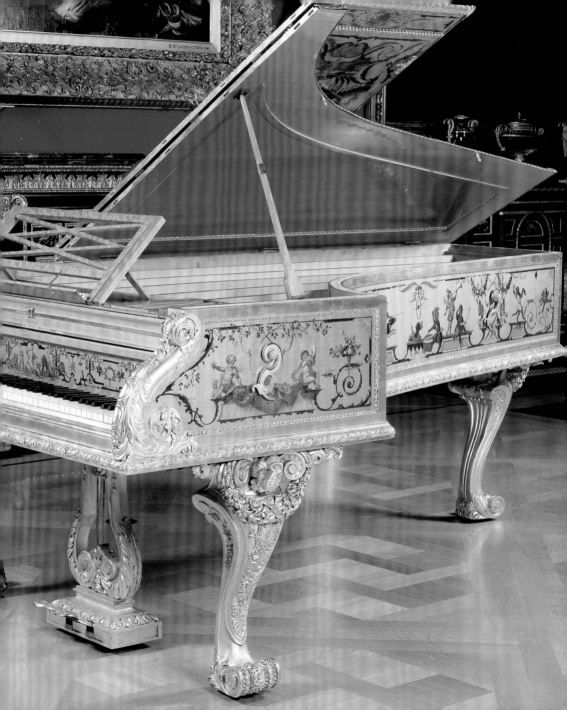

The celebrated composer, pianist and conductor Felix Mendelssohn visited Buckingham Palace five times during the 1840s. He not only played and arranged music for the royal couple, he also played with them and heard them perform. He was genuinely impressed. Of the Prince's organ-playing he wrote 'many an organist could have learnt something', while of the Queen's singing of one of his songs he added 'she had done it so well … as one seldom hears it done.'

This is one of a number of pieces that Mendelssohn especially arranged for the Queen and Prince to play as a duet. The royal couple were shocked to hear of the composer's untimely death. 'We read & played that beautiful "Lied ohne Worte", which poor Mendelssohn arranged and wrote out himself for us this year,' wrote the Queen. 'To feel, when one is playing his beautiful music, that he is no more, seems incomprehensible.'

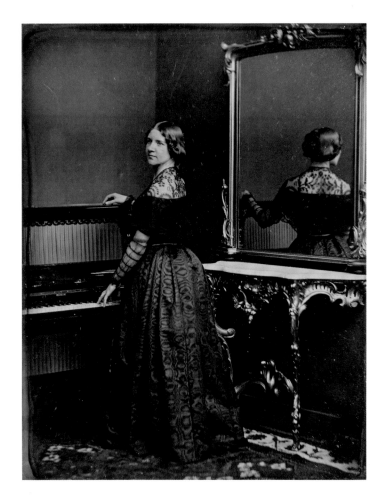

WILLIAM EDWARD KILBURN
(1818–1891)
Jenny Lind standing at a piano,
1848
Daguerreotype, 11.5 x 9.1cm
RCIN 2932510

The Queen and Prince Albert
were so impressed by the
Swedish soprano, Jenny Lind
(1820–1887), that in 1847 they
attended all sixteen of her
London performances, once
interrupting dinner with the
Prime Minister, Lord John
Russell, at Buckingham
Palace, in order not to miss
her. This daguerreotype, an
early form of photograph,
ingeniously uses a mirror to
show a double view of the
singer at a piano.

RIGHT:
RICHARD BEARD (1801–1885)
Tyrolean singers, 1851–2
Hand-coloured enamelled
daguerreotype, 14 x 10.2cm
RCIN 2932501

Queen Victoria had first
seen this troupe of Tyrolean
singers as a girl at Kensington
Palace. For the Queen's
birthday at Osborne in 1852,
her mother, the Duchess of
Kent, arranged for the singers
to serenade her at breakfast.
'Victoria appeared very much
pleased with the surprise,'
the Duchess wrote. This
hand-coloured enamelled
daguerreotype was purchased
by the Queen in the same
year.

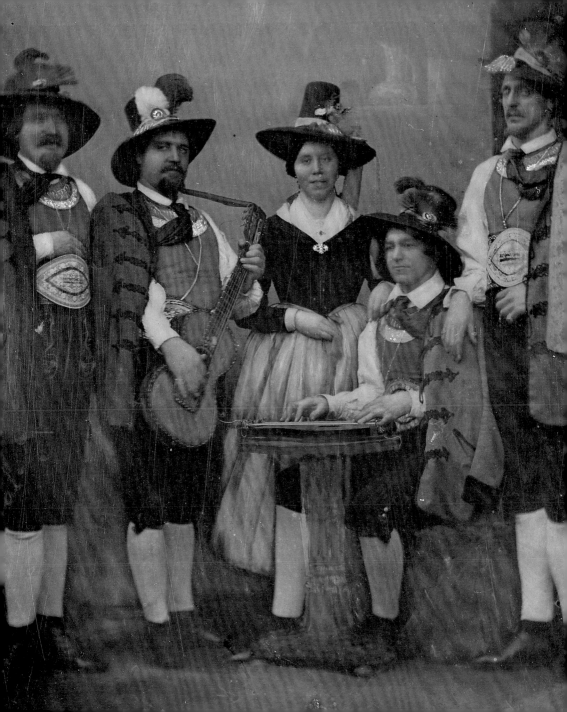

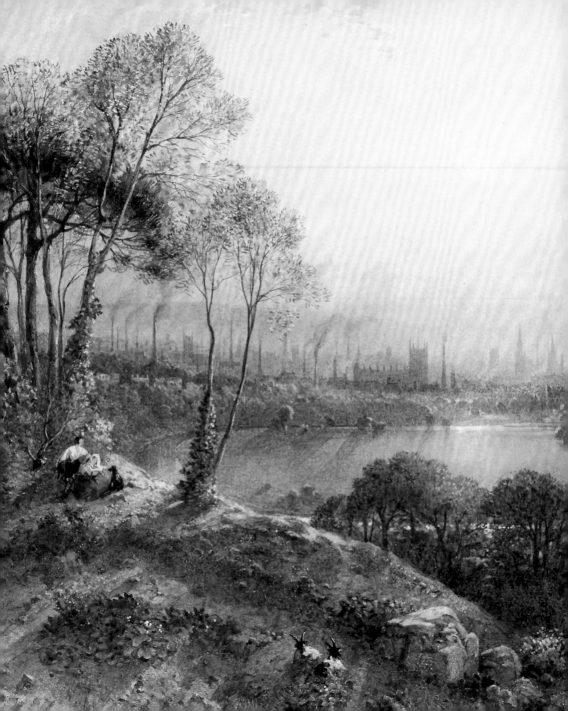

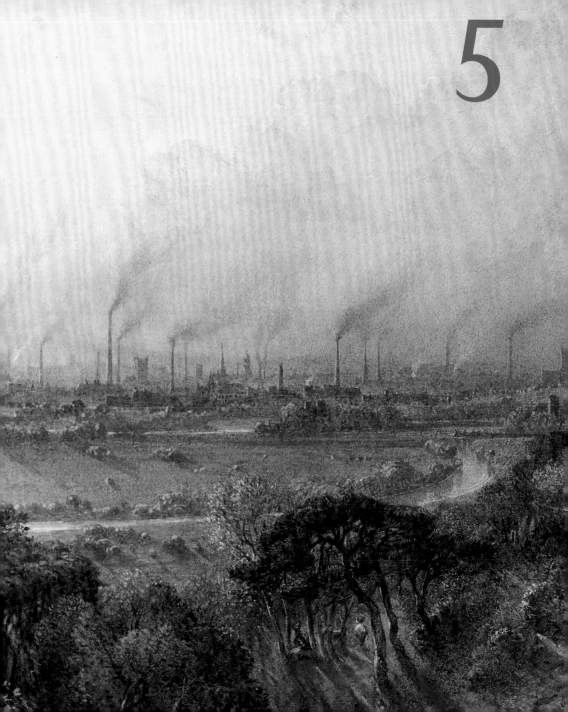

5

THE WORLD
AT LARGE

THE QUEEN AND PRINCE were extremely fond of their home and family life. But both took an active interest in the people, places and events in the world at large – all of which found reflection in their patronage of art. As Sovereign, the Queen paid particular attention to anything affecting her realm and subjects, both at home and abroad. She followed the events of the Crimean War in 1853–6 and the Indian Rebellion in 1857–8 with great concern, and took steps to show her gratitude to those who had fought and suffered on her behalf. For someone often portrayed as narrow-minded, Queen Victoria was remarkably open in her encounters with people from other parts of the world and showed motherly care for individuals who came under her personal protection. Any travels made by the royal couple were carefully documented, most often in watercolours destined for the Queen's Souvenir Albums. These mementos range from a record of a gala performance at the Paris Opéra to a view of the chimneys of Manchester. The world of industry was of special interest to Prince Albert, whose desire to see closer collaboration between artists, designers and manufacturers led him to organise the Great Exhibition of 1851. Held in the giant glass and iron structure of the Crystal Palace, the Exhibition brought together some 17,000 exhibitors from around the world and was seen by six million people.

EUGENE LAMI (1800–1890)
The Opening of the Great Exhibition, 1 May 1851, 1851
Watercolour, 62.8 x 49.6cm
RL 13029

The opening of the Great Exhibition of the Works of Industry of All Nations took place on 1 May 1851. On a raised dais in the central crossing of the Crystal Palace, built in Hyde Park and enclosing several of the park's mature trees, the Queen received the report of the Commissioners, led by Prince Albert. The Queen described the day as 'one of the greatest and most glorious days of our lives'.

PAGES 102–3:
WILLIAM WYLD
View of Manchester from Kersal Moor, 1852 (detail; pp.122–3)

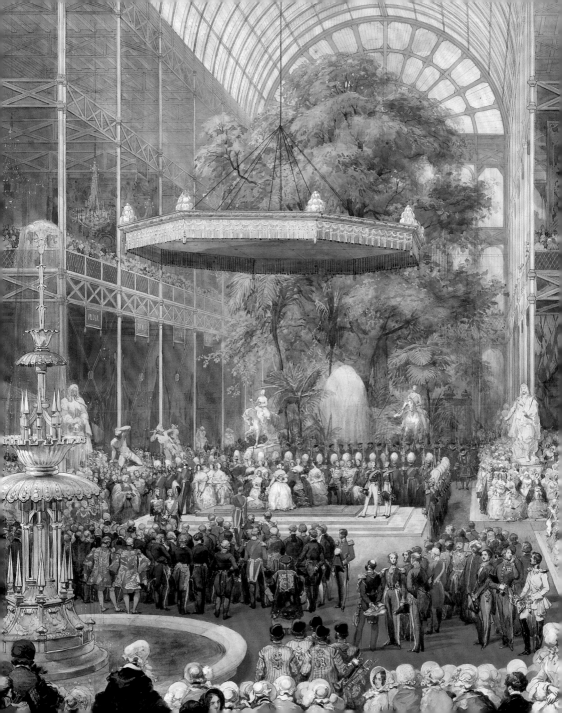

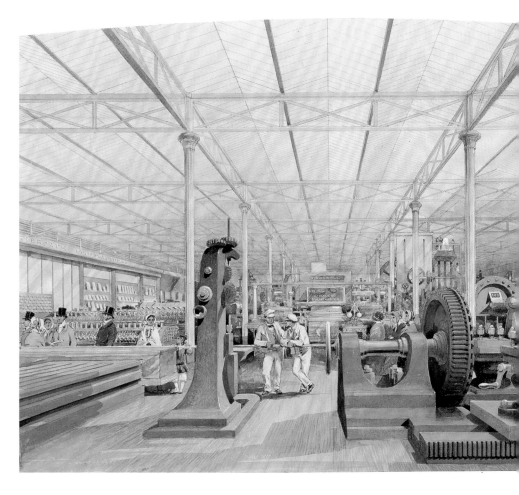

Louis Haghe (1806–1885)
The Great Exhibition:
Moving Machinery, 1851
Watercolour and bodycolour over pencil,
29.5 x 54.5cm
RL 19979

The Machinery Court was considered a particular marvel of the Great Exhibition. Inside, visitors were dwarfed by monumental machines incorporating the latest technology. This watercolour by Louis Haghe was one of a number of views commissioned by Prince Albert to be reproduced as high-quality lithographs for sale to the public. Other permanent records of the Exhibition included Wyatt's volume illustrating the finest products and works of art on show. The book's magnificent binding (opposite) was the work of one of the exhibitors, David Batten of Clapham Common.

Sir (Matthew) Digby Wyatt
(1820–1877)
*The Industrial Arts of the Nineteenth
Century: a Series of Illustrations of
the Choicest Specimens… at the Great
Exhibition of Works of Industry,
1851*, London: Day & Son, 1851–3

Dark brown goatskin binding with
green and red decorations and
extensive gold tooling,
50.8 x 35.2cm
RCIN 817104.a–b

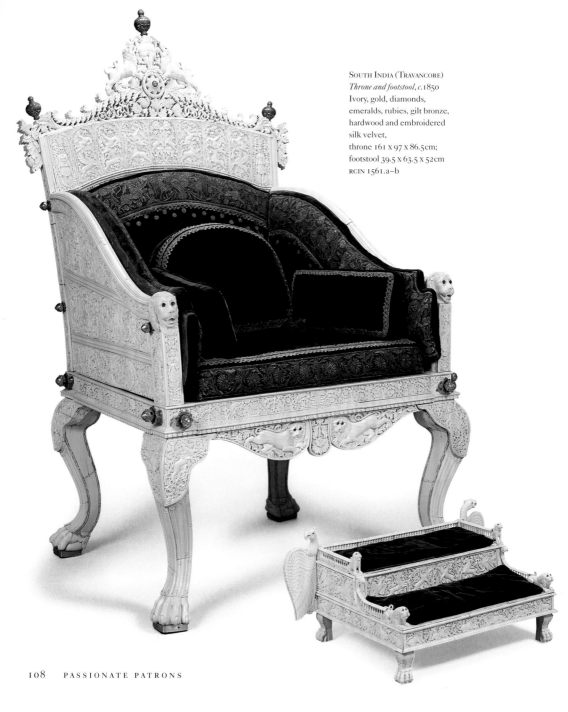

SOUTH INDIA (TRAVANCORE)
Throne and footstool, c.1850
Ivory, gold, diamonds,
emeralds, rubies, gilt bronze,
hardwood and embroidered
silk velvet,
throne 161 x 97 x 86.5cm;
footstool 39.5 x 63.5 x 52cm
RCIN 1561.a–b

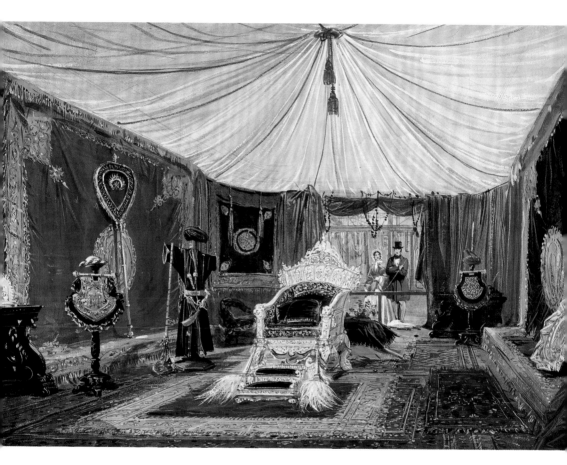

Joseph Nash (1809–1878)
*The Great Exhibition:
India No.1*, 1851
Watercolour and bodycolour
over pencil, 35 x 51.5cm
RL 19968

Many countries had dedicated areas at the Great Exhibition. This watercolour by Joseph Nash shows an exotic tented space in the India section. Clearly visible in the centre is the ivory and jewel-encrusted throne and footstool (opposite and overleaf) that was presented to Queen Victoria by the Maharaja of Travancore. When the Queen became Empress of India in 1876 she chose to be shown seated on this throne for the official photograph.

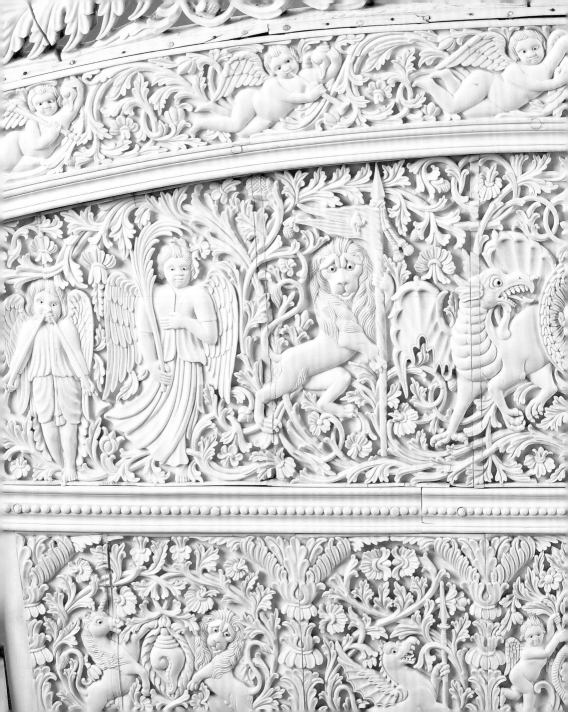

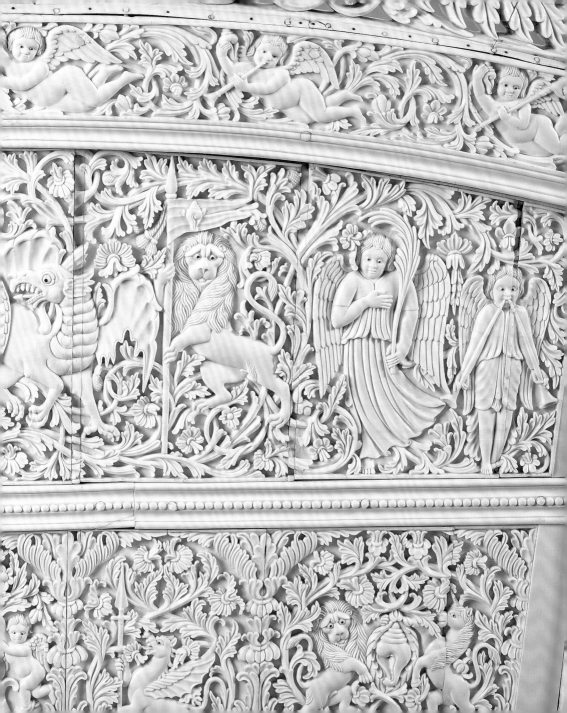

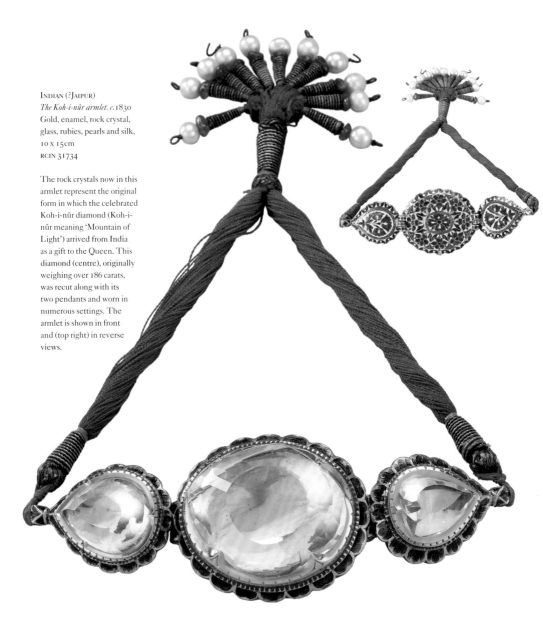

INDIAN (?JAIPUR)
*The Koh-i-nûr armlet. c.*1830
Gold, enamel, rock crystal,
glass, rubies, pearls and silk,
10 x 15cm
RCIN 31734

The rock crystals now in this
armlet represent the original
form in which the celebrated
Koh-i-nûr diamond (Koh-i-
nûr meaning 'Mountain of
Light') arrived from India
as a gift to the Queen. This
diamond (centre), originally
weighing over 186 carats,
was recut along with its
two pendants and worn in
numerous settings. The
armlet is shown in front
and (top right) in reverse
views.

R. & S. Garrard & Co.
The Oriental Tiara,
1853 and later
Rubies, diamonds and gold,
6.5 x 15.7 x 16.8cm
RCIN 200174

The inspiration for the design of this tiara, which includes 'Moghul' arches framing lotus flowers, came from Prince Albert who had been greatly impressed by the Indian jewels presented to the Queen by the East India Company at the conclusion of the Great Exhibition. This was one of many instances where the Prince supervised the design and setting of the Queen's jewellery. 'Albert has such taste & arranges everything for me about my jewels,' she wrote.

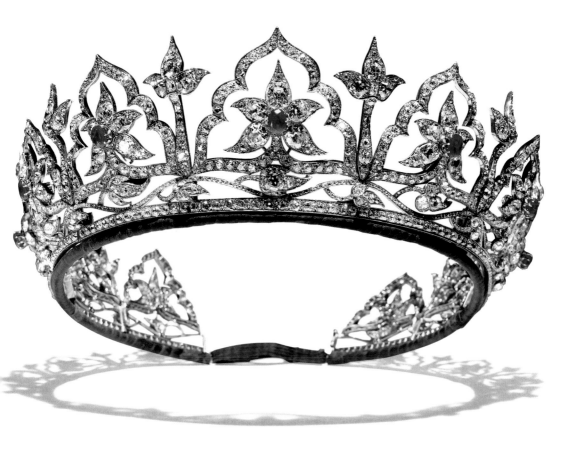

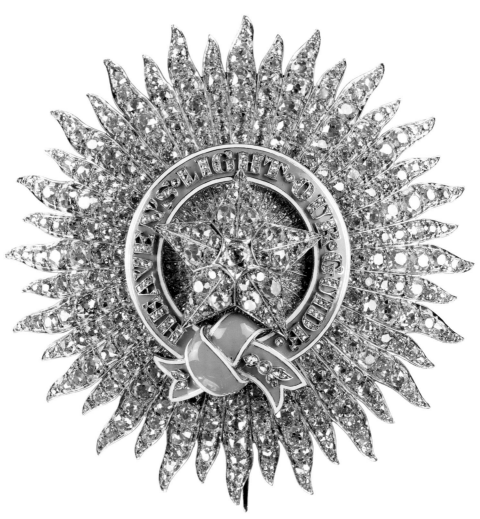

R. & S. GARRARD & CO. (?)
Star of the Order of the Star of India, 1861
Gold, yellow and white diamonds, silver
and enamel, 6.8 x 6.7cm
RCIN 441296

Following the suppression of the Indian
Rebellion in 1858, and the winding up
of the East India Company, which
had previously controlled half the
subcontinent, Westminster assumed
direct government of India. Eager to
establish a new order of chivalry to
cement good relations between the

British Crown and loyal Indian subjects,
Prince Albert suggested its name (Order
of the Star of India) and set about
designing its insignia and robes. This
magnificent jewel-encrusted star was
made for Queen Victoria for the first
investiture on 21 November 1861.

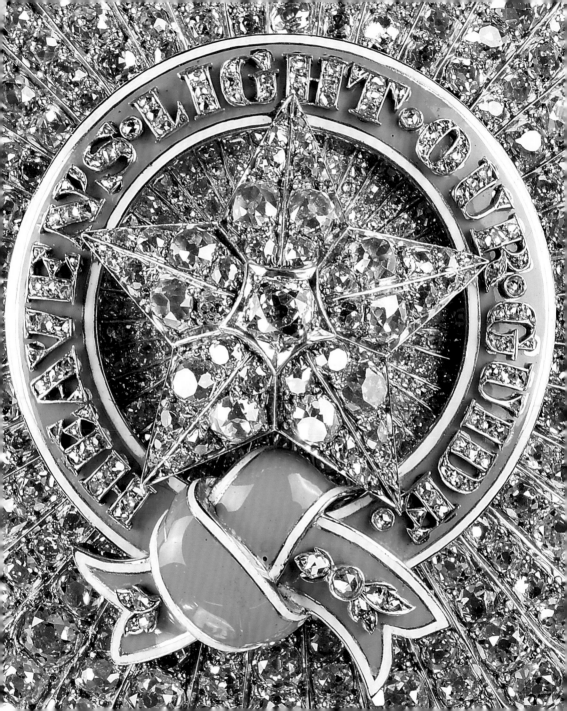

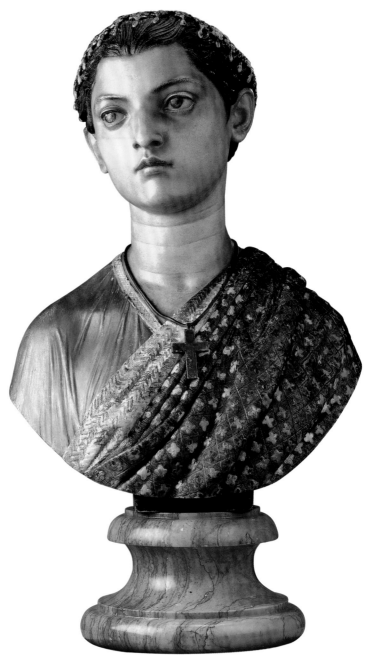

CARLO, BARON MAROCHETTI
(1805–1867), sculptor and
WILLIAM H. MILLAIS
(1828–1899), watercolourist
Princess Gouramma of Coorg,
1855
Marble, painted in
watercolour and gilded,
height excl. socle and block
68.6cm
RCIN 41535

Princess Gouramma
(1841–64), the daughter of
the deposed Rajah of Coorg,
travelled to London in 1852.
She was presented to Queen
Victoria and accommodated
at Buckingham Palace,
where on 30 June she was
baptised in the Private
Chapel. Queen Victoria was
one of her godparents. This
marble bust, painted with
watercolour to make it
appear more lifelike, shows
the Princess with a crucifix
on prominent display. The
painter, W.H. Millais, was
the elder brother of the more
famous artist John Everett
Millais.

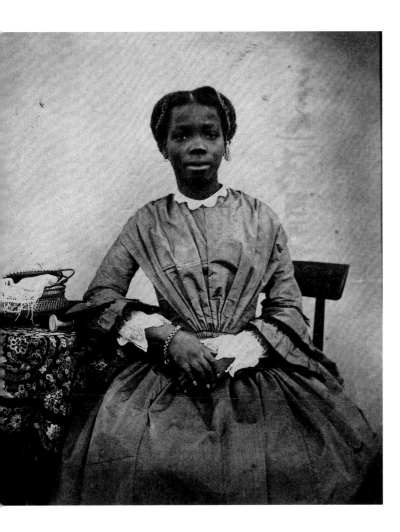

WILLIAM BAMBRIDGE
(1819–1879)
Sarah Forbes Bonetta, 1856
Albumen print
13.3 x 11.8cm (image)
RCIN 2906613

This girl, known both as
Sarah Forbes Bonetta and
Sally Bonetta Forbes
(*c*.1843–80), was probably
the daughter of a West
African chief. She was
captured at about the age of
five and taken into slavery by
the King of Dahomey. Given
by the King to a British
envoy, Captain Frederick
Forbes, who had arrived on
the HMS *Bonetta* to negotiate
an end to the slave trade, the
child returned to England
with him and was given a
new name. There she was
presented to Queen Victoria,
who decided to take
responsibility for her
protection and education.
Sarah married in 1862 and
later had a daughter, Victoria,
to whom the Queen acted as
godmother.

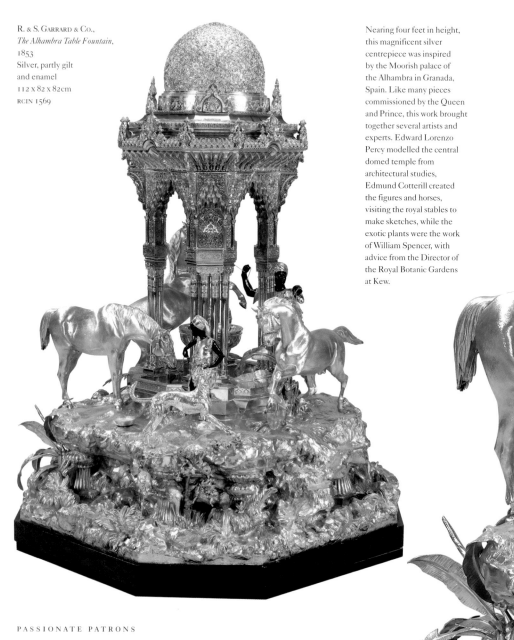

R. & S. GARRARD & CO.,
The Alhambra Table Fountain,
1853
Silver, partly gilt
and enamel
112 x 82 x 82cm
RCIN 1569

Nearing four feet in height, this magnificent silver centrepiece was inspired by the Moorish palace of the Alhambra in Granada, Spain. Like many pieces commissioned by the Queen and Prince, this work brought together several artists and experts. Edward Lorenzo Percy modelled the central domed temple from architectural studies, Edmund Cotterill created the figures and horses, visiting the royal stables to make sketches, while the exotic plants were the work of William Spencer, with advice from the Director of the Royal Botanic Gardens at Kew.

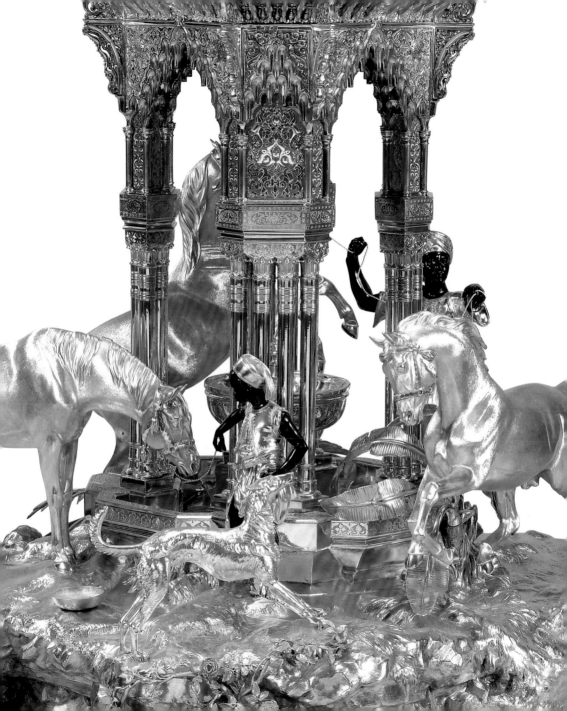

EUGENE LAMI (1800–1890) and
JULES DIÉTERLE (1811–1899)
*Gala Performance at the Paris
Opéra, 21 August 1855*, 1855
Watercolour and bodycolour
over pencil, 35.6 x 57cm
RL 20071

The Queen and Prince enjoyed
a rapturous welcome during
their State Visit to France in
1855. This watercolour,
commissioned by the Emperor
Napoleon III, records a gala
performance of opera and ballet
extracts given in their honour.
The Queen enjoyed the lavish
arrangements at the theatre,
particularly the richly
decorated box in which they
sat. But she was unimpressed
with the performance, which
she thought too long.

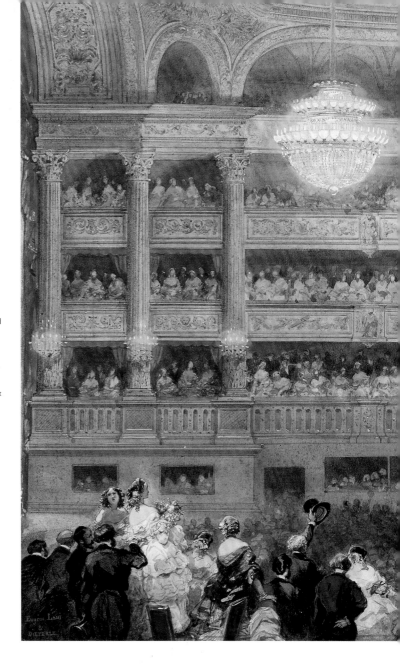

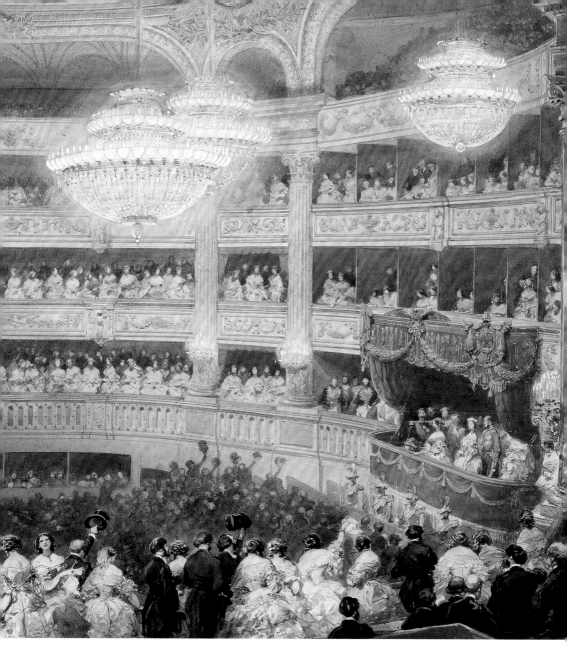

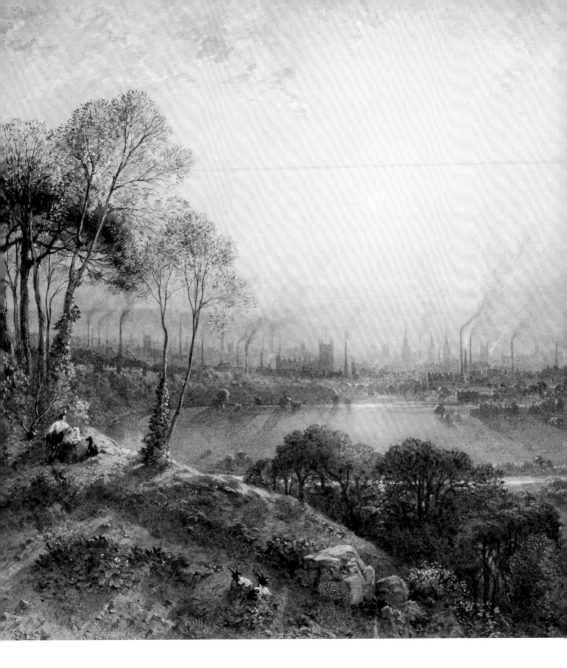

WILLIAM WYLD (1806–1889)
*View of Manchester from Kersal
Moor, with rustic figures and
goats*, 1852
Watercolour and bodycolour
with gum arabic and some
scraping out over pencil,
31.7 x 49cm
RL 20223

Queen Victoria visited
Manchester in 1851 and
was astonished by its size.
In this watercolour, especially
commissioned for one of her
Souvenir Albums, in which all
her journeys were recorded,
the artist William Wyld sets
the smoking chimneys of the
city as the horizon to an idyllic
foreground landscape. He also
bathes the scene in a golden
sunrise reminiscent of the oil
paintings of the seventeenth-
century master, Claude
Lorrain.

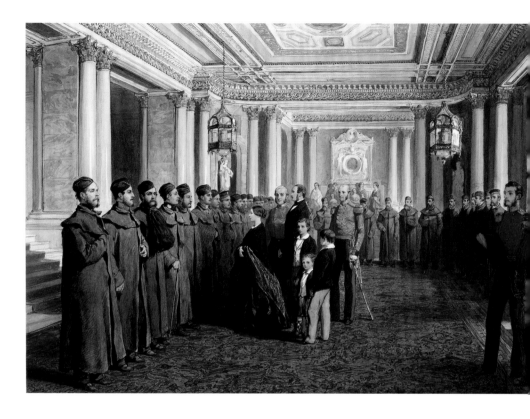

George Housman Thomas
(1824–1868)
*Buckingham Palace: Queen
Victoria and Prince Albert
inspecting wounded Grenadier
Guardsmen, 20 February 1855,*
1855
Watercolour, bodycolour and
gum arabic over pencil,
33.1 x 48.5cm
RL 16782

George Housman Thomas
was commissioned to record
this meeting between the
Queen and thirty-two
wounded soldiers, who had
just returned from the
Crimea. The Queen, who
took a close interest in the
war, was deeply moved.
'It made one's heart bleed,'
she wrote in her Journal.

As a direct result, she later
instituted the Victoria Cross
to reward members of her
armed forces, regardless
of rank, 'For Valour'. The
inspection took place in
the Grand Hall, newly
redecorated to the designs
of Ludwig Gruner in 1853.

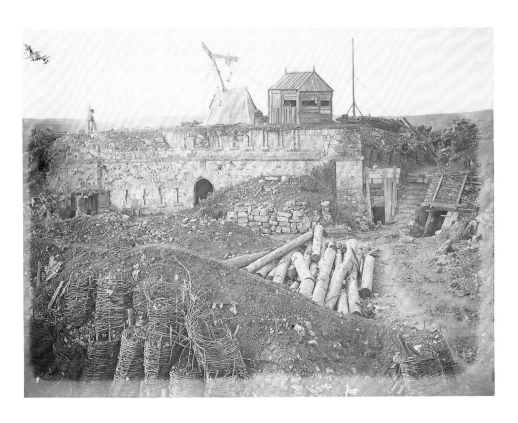

JAMES ROBERTSON
(1813–1888)
*Tower of the Malakoff,
Sebastopol*, 1855
Salted paper print,
23.6 x 28.9cm
RCIN 2500688

Taken in the aftermath of the
battle for the Russian naval
base of Sebastopol in the
Crimea, this early example of
war photography shows the
devastated remains of the
Tower of Malakoff, one of
the city's defences. The

scene of some of the most
protracted fighting of the
Crimean War, the siege
and eventual capture of
Sebastopol led to the Russian
capitulation – the cause of
much rejoicing in Britain.

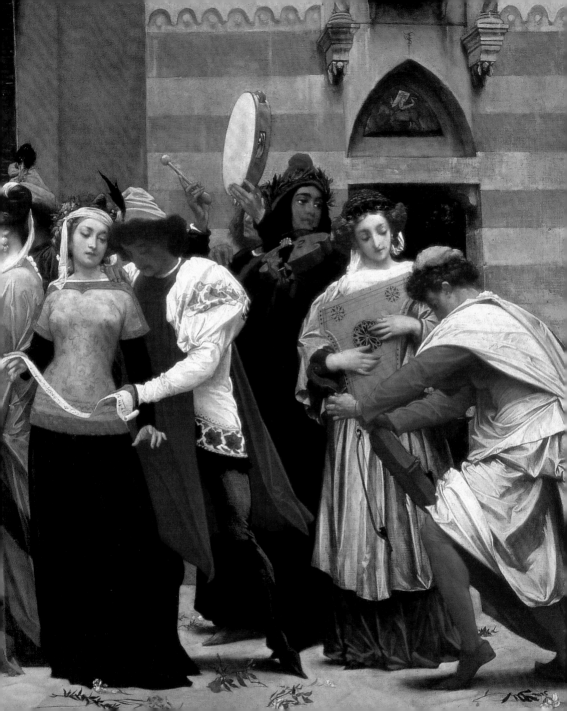

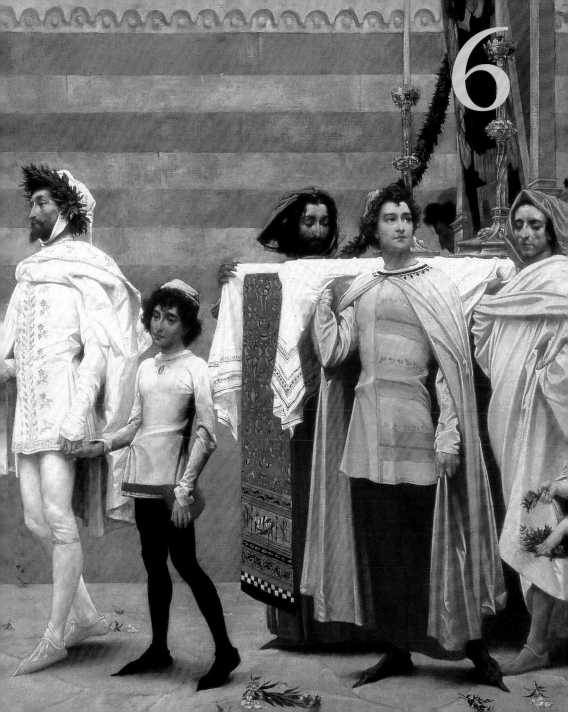

COLLECTING

PAGES 126–7:
FREDERIC LEIGHTON, 1ST
BARON LEIGHTON OF STRETTON
*Cimabue's Madonna Carried in
Procession*, 1853–5
(detail; pp.140–1)

WHILE QUEEN VICTORIA and Prince Albert shared a passion for collecting, their tastes were not the same. The Queen took greatest delight in portraits, particularly of family and friends, and she was always fascinated by objects that related in some way to her personal experience or sentimental attachments. In painting she was attracted to crowded and colourful narrative pictures. Prince Albert, on the other hand, was rather more of a connoisseur. He was a pioneer in the study of Early Italian and German art and built up a significant collection at a time when such works were generally undervalued. He was less fortunate in acquiring works by his life-long hero, Raphael, whose paintings invariably fetched sums far beyond his budget. A number of Raphael-inspired works did, however, enter the collection, and the Prince also set about the scholarly task of compiling a complete collection of reproductions of the master's work. This curatorial impulse was one shared by the Queen and Prince. In the Print Room at Windsor Castle, for example, early printed portraits of English and foreign rulers were meticulously classified, while at Buckingham Palace the pictures were thoughtfully re-hung and given matching frames. And when it came to building Osborne House, the couple ensured that one of its central features was a broad corridor specifically designed to display their collection of modern sculpture.

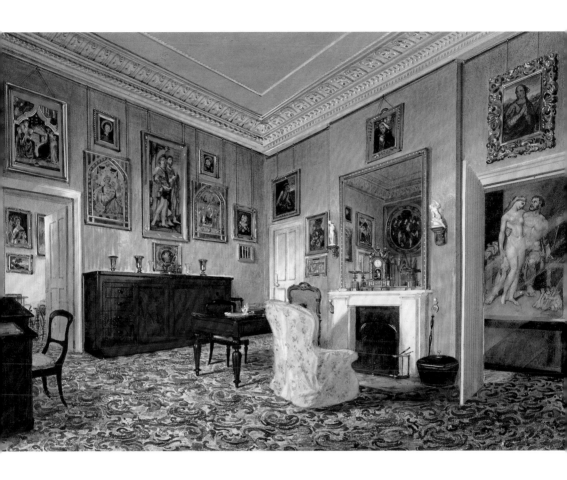

JAMES ROBERTS (*c.*1800–1867)
*Osborne: the Prince's Dressing
and Writing Room*, 1851
Watercolour and bodycolour,
24.3 x 36.8cm
RL 26224

The Prince's Dressing and
Writing Room at Osborne
was hung with the best of his
collection of early Italian
paintings. Included, on the
left next to the open door, is
The Madonna of Humility with

Angels, attributed to Strozzi
(see p. 130) and, above the
closed door, Perugino's *St
Jerome* (see p. 136). A glimpse
through into the Queen's
Sitting Room, far left, shows
her portrait by Winterhalter.

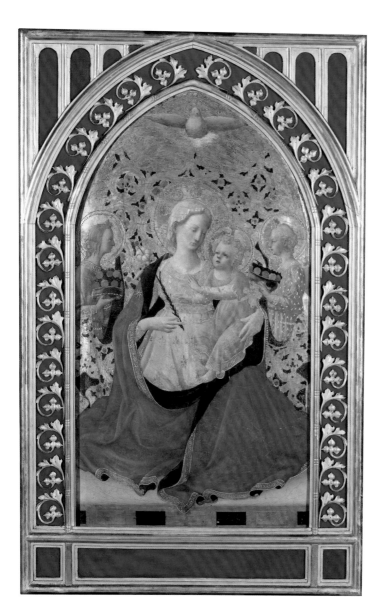

Attributed to
ZANOBI DI BENEDETTO, called
ZANOBI STROZZI (1412–1468)
*The Madonna of Humility with Angels, c.*1440–50
Tempera and tooled gold on panel, 87.4 x 49.5cm
RCIN 400039

Prince Albert acquired this panel as a work by the celebrated Florentine artist, Fra Angelico, although it has since been attributed to one of that master's associates, Zanobi Strozzi. It shows the Madonna and Child seated before an elaborately decorated cloth of honour and flanked by angels. The architectural frame surrounding the panel, in which gold ornaments are set against a ground matching the blue of the Virgin's mantle, was probably designed by the Prince's artistic adviser, Ludwig Gruner.

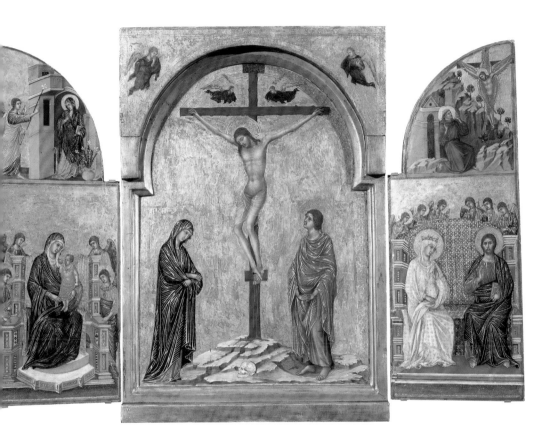

Ducci di Buoninsegna
(active 1278–before 1319)
and Assistants
*Triptych: The Crucifixion and
other scenes*, *c*.1302–8
Tempera on panel,
Central panel 44.9 x 31.4cm,
round headed; spandrel
above 13.9 x 34.9cm;
wings 44.8 x 16.9cm
RCIN 400095

Bought by Prince Albert in
1845, this was the first work
by the early fourteenth-
century Sienese artist,
Duccio, to enter a British
collection. Still showing the
influence of earlier icon
painting, the central image
of the Crucifixion is flanked
by two wings dominated, on
the left, by a depiction of the

Virgin and Child, and on the
right, by Christ and the
Virgin Enthroned. When not
in use, these wings would
have folded over the main
panel to protect it.

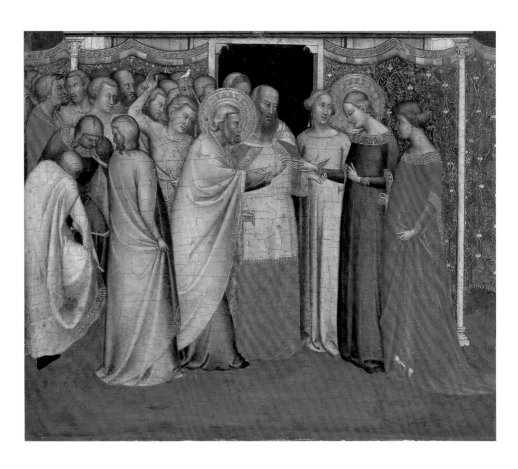

BERNARDO DADDI
(active *c*.1312/20–*c*.1348)
The Marriage of the Virgin,
c.1339–42
Tempera on panel,
25.5 x 30.7cm
RCIN 406768

Painted by Bernardo Daddi as
one of a number of small scenes
portraying the life of the Virgin
Mary, this work was originally
part of the altarpiece of
Florence Cathedral. It shows
the young Virgin Mary in blue

on the right, being joined in
marriage to the elderly Joseph.
The Queen used Prince
Albert's artistic adviser,
Ludwig Gruner, to help
purchase this work for her
husband's birthday in 1846.

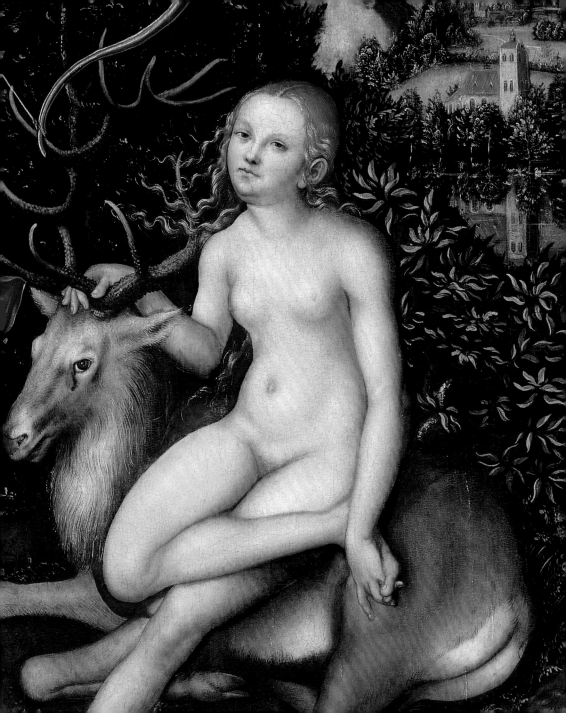

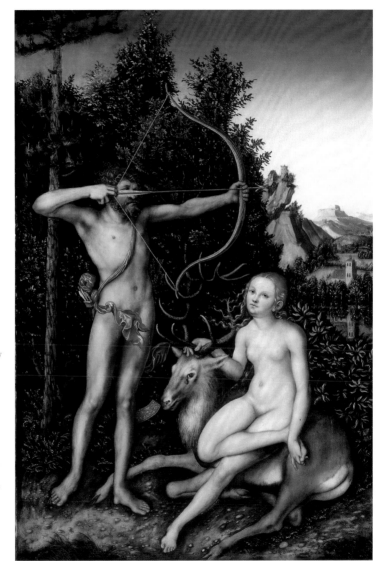

LUCAS CRANACH THE ELDER
(1472–1553)
*Apollo and Diana, c.*1526
Oil on beech panel,
83.8 x 56.5cm
RCIN 407294

Prince Albert was particularly
interested in the work of
Lucas Cranach, one of the
leading figures of the
German Renaissance. As
court artist to the Electors
of Saxony, Cranach had
also painted for the Prince's
ancestors. In the landscape
background of this depiction
of the mythological gods
Apollo and Diana, the Prince
may have recognised an
idealised vision of his
homeland, complete with
pine trees, a church and a
castle perched on a rocky
outcrop.

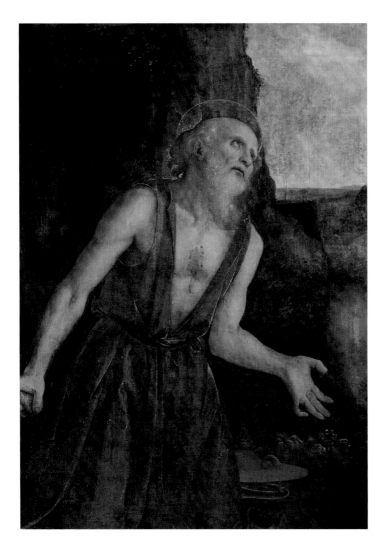

PIETRO DI CRISTOFORO
VANNUCCI, called PERUGINO
(*c*.1450–1523)
St Jerome in Penitence,
c.1480–5
Glue-based medium (?) on
fine-weave canvas laid on
panel, 79.4 x 58.7cm
RCIN 403469

Named after his birthplace
of Perugia, Perugino's
greatest impact on sixteenth-
century Italian painting was
made through his most
famous pupil, Raphael. In
this image of the penitent
St Jerome praying in the
wilderness we can see the
delicacy and gracefulness for
which Perugino himself was
famed. While the royal
couple could never afford a
work by Raphael, this picture
– purchased by the Queen
for the Prince's twenty-
seventh birthday –
incorporated many of the
qualities of early Renaissance
art that Prince Albert most
admired.

HANS BALDUNG (GRIEN)
(1484/5–1545)
Portrait of a Young Man with a Rosary, 1509
Oil on panel, 51.6 x 36.9cm
RCIN 405758

In 1847 Prince Albert acquired the entire art collection of a relative, Prince Ludwig von Oettingen-Wallerstein. Prince Albert had been the guarantor of a loan secured on the collection, which was offered for sale in London. When no buyer was found for it, the Prince became the owner of some 100 pictures. Most were works he would not have chosen for himself, but the collection included a Memling *Madonna* and this arresting portrait by Albrecht Dürer's most able assistant, Baldung Grien.

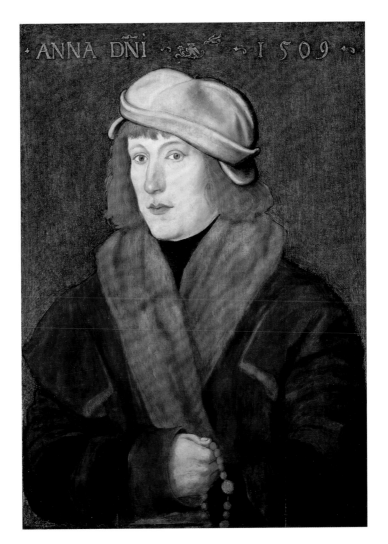

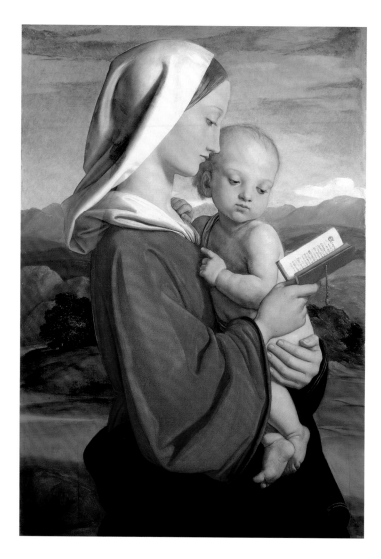

WILLIAM DYCE (1806–1864)
The Madonna and Child, 1845
Oil on canvas, 80.2 x 58.7cm
RCIN 403745

A number of contemporary
artists shared Prince Albert's
admiration for the art of
Raphael. This depiction of
the Madonna and Child by
the Scottish painter, William
Dyce, draws heavily on the
simple lines, idealised beauty
and clear colours of the
sixteenth-century master.
The resemblance was noted
by the Queen who described
the painting as 'quite like
an old master, and in the
style of Raphael – so chaste
and exquisitely painted.'

RIGHT:

BERLIN, ROYAL PORCELAIN
MANUFACTORY (K.P.M.),
after RAPHAEL
*Madonna and Child
(The 'Colonna' Madonna)*,
*c.*1848–58
Porcelain, 74.2 x 58.3cm
RCIN 404017

An inscription on the back
of this version of Raphael's
painting (now in Berlin,
Gemäldegalerie), known as
the 'Colonna' Madonna after
its original owners, states that
it was Prince Albert's
favourite work by the master.
As pictures by Raphael were
always well beyond the
Prince's means, copies such
as this one, painted on
porcelain, served as useful
substitutes.

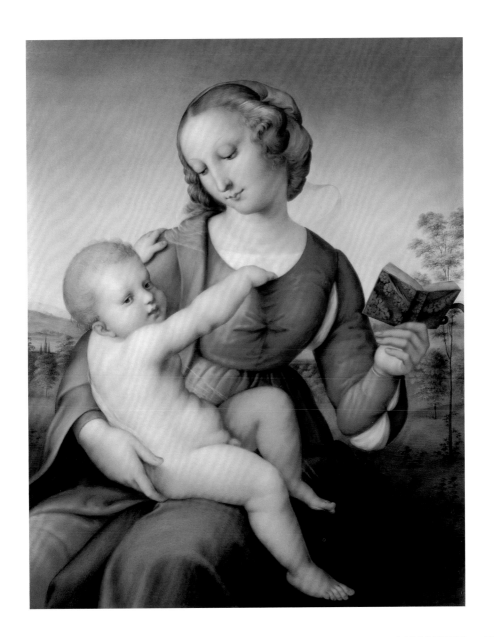

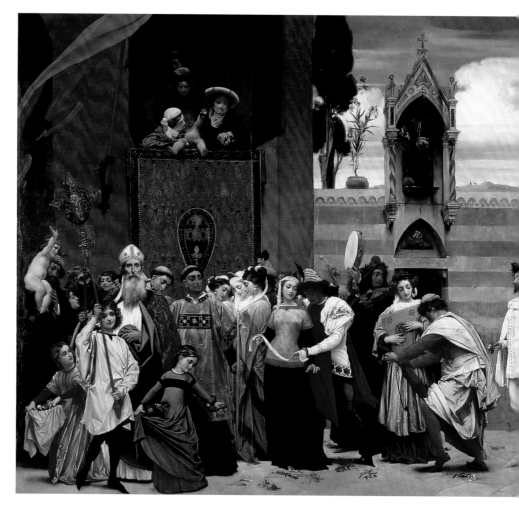

FREDERIC LEIGHTON,
1ST BARON LEIGHTON OF STRETTON
(1839–1896)
*Cimabue's Madonna Carried
in Procession*, 1853–5
Oil on canvas, 246.5 x 537cm
RCIN 401478

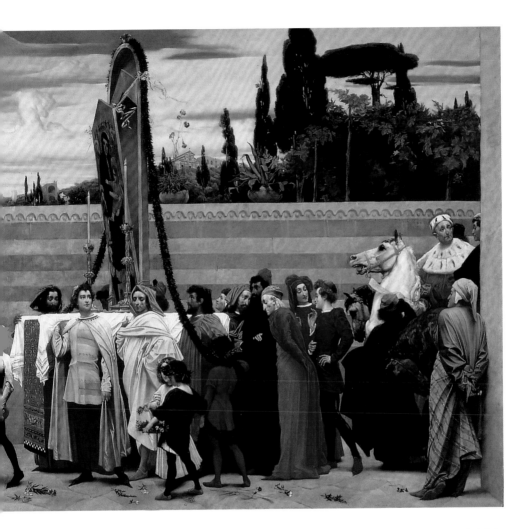

Queen Victoria and Prince Albert often bought pictures shown at the annual exhibitions at the Royal Academy. In 1855 they visited privately before the opening: 'There was a very big picture, by a young man, called Leighton, his 1st attempt, at the age of 20,' the Queen wrote. 'Albert was enchanted with it – so much so that he made me buy it.' It is easy to see how Leighton's meticulously researched depiction of the *Rucellai Madonna* being processed through the streets of thirteenth-century Florence would have appealed to the Queen and her husband. Full of colour and scholarly detail, it also imagines the artist Cimabue, dressed in white, leading his young pupil Giotto by the hand, while on the far right Dante looks on.

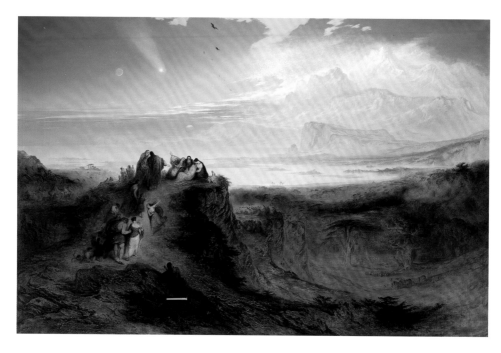

JOHN MARTIN (1789–1854)
The Eve of the Deluge, 1840
Oil on canvas,
144.3 x 218.5cm
RCIN 407176

Prince Albert made
numerous visits to the
London studio of the
visionary painter, John
Martin. The artist valued the
Prince's opinion, and it may
have been on his advice that
Martin made a trilogy of the

Old Testament story of the
Deluge. This picture, the
first of the three, shows Noah
and his family huddled on a
rocky outcrop witnessing the
prophetic appearance of the
sun, the moon and a comet –
signs of the coming disaster.

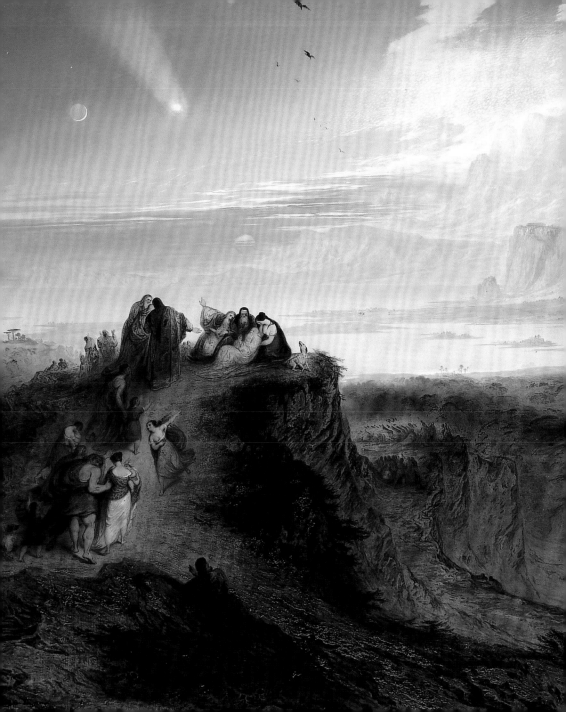

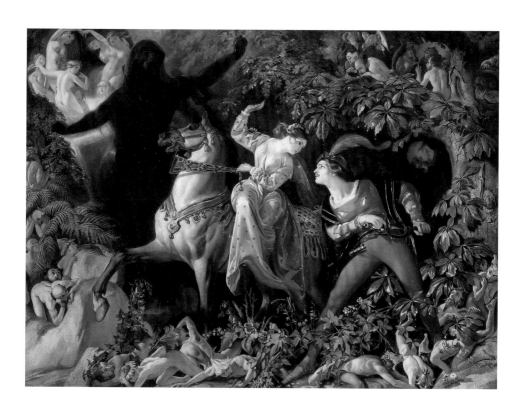

Daniel Maclise (1806–1873)
A scene from Undine, 1843
Oil on panel, 44.2 x 60.9cm
RCIN 405638

The first pictures Queen
Victoria bought were by
Daniel Maclise, a specialist in
scenes from literature. In this
work, purchased by the
Queen for Prince Albert's
twenty-fourth birthday, the
artist weaves a tapestry-like
fantasy about the German
tale of Undine – a water spirit.
She trades her immortal soul
to marry a handsome knight,
despite the opposition of her
uncle, the monstrous
Kühleborn, who is seen rising
from the river on the left.

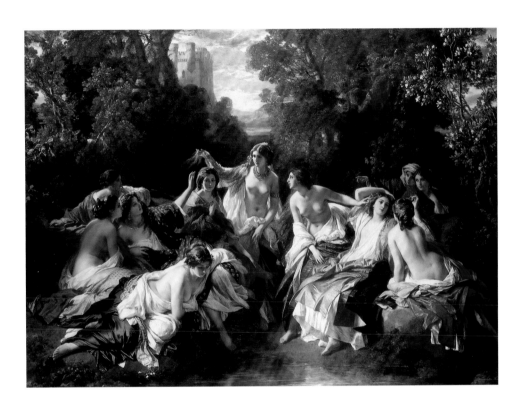

Franz Xaver Winterhalter
(1805–1873)
Florinda, 1852
Oil on canvas,
179.3 x 243.9cm
RCIN 404860

Proof that Queen Victoria was not averse to nudity in art, this sumptuous picture was purchased by her as a present for Prince Albert. Showing a scene from a legend set in Medieval Spain, the beautiful dark-haired Florinda (centre left, directly under the castle) and her companions are spied upon by King Rodrigo, who hides in the bushes. According to the story it was the King's jealous love for Florinda that provoked the Moorish invasion of Spain.

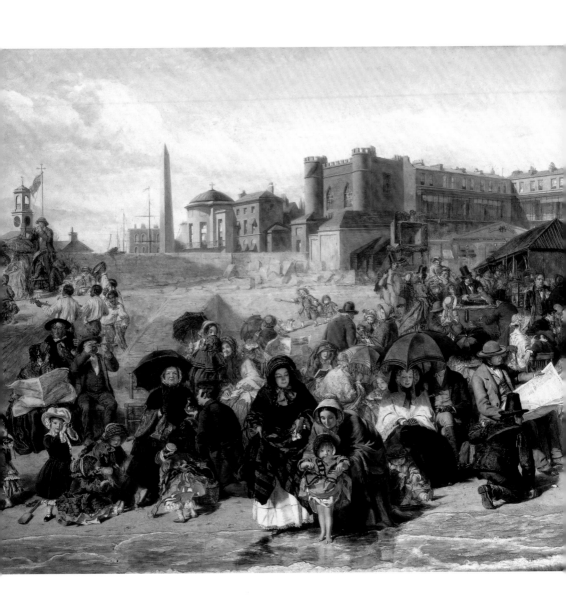

WILLIAM POWELL FRITH
(1819–1909)
*Ramsgate Sands: 'Life at the
Seaside'*, 1851–4
Oil on canvas, 77 x 155.1cm
RCIN 405068

Depicting modern society
in all its variety, this
meticulously detailed image
of the Kentish resort of
Ramsgate proved such
a success at the Royal
Academy that a guard-rail
had to be installed to protect
it from the crowds. It was
initially bought by the art
dealers Messrs Lloyd for
£1,000, but when Queen
Victoria saw the picture and
expressed an interest in
buying it, they agreed to
sell it to her. However, they
insisted on keeping the
rights to engrave the work,
and the considerable profits
from the resulting prints.

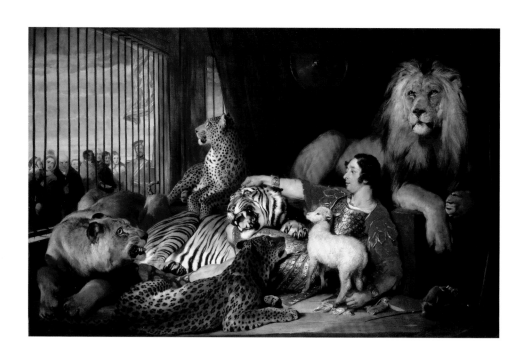

SIR EDWIN LANDSEER
(1803–1873)
*Isaac van Amburgh and
his Animals*, 1839
Oil on canvas,
113.7 x 174.8cm
RCIN 406346

This was the first of over
forty pictures the Queen
commissioned from Sir
Edwin Landseer. Landseer
is best known as an animal
painter and in this work,
showing the American lion-
tamer Isaac van Amburgh,

his skill at capturing the
individual character and
anatomy of the animals is
astonishing. Queen Victoria
found Van Amburgh's act
thrilling. 'One can never see
it too often, for it is different
each time,' she wrote.

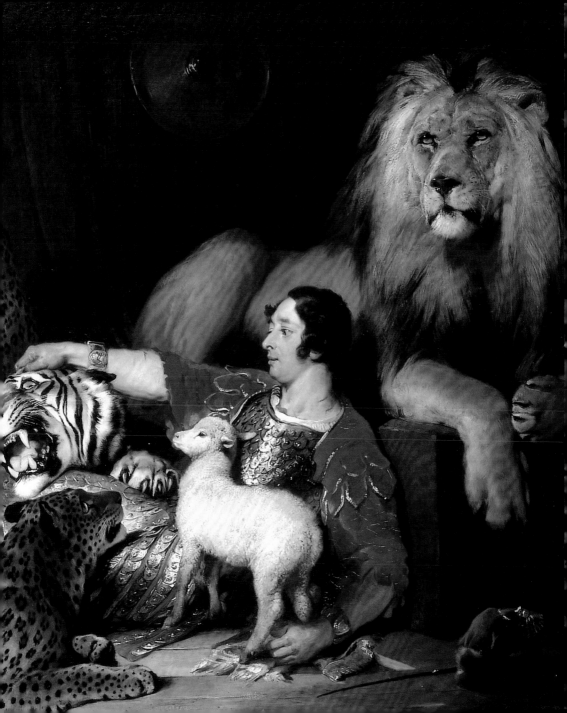

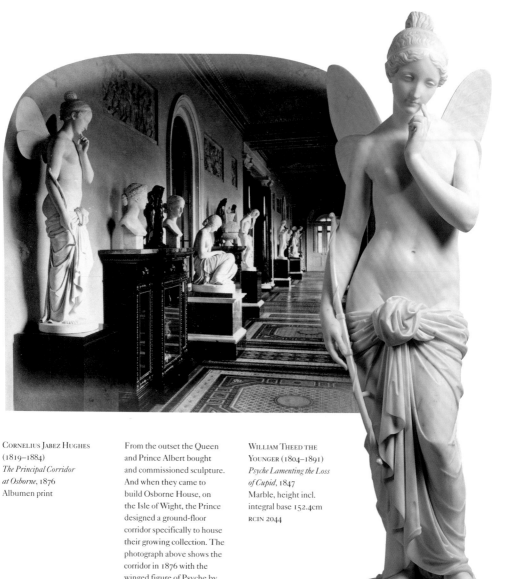

CORNELIUS JABEZ HUGHES
(1819–1884)
*The Principal Corridor
at Osborne*, 1876
Albumen print

From the outset the Queen
and Prince Albert bought
and commissioned sculpture.
And when they came to
build Osborne House, on
the Isle of Wight, the Prince
designed a ground-floor
corridor specifically to house
their growing collection. The
photograph above shows the
corridor in 1876 with the
winged figure of Psyche by
William Theed clearly visible
in the foreground.

WILLIAM THEED THE
YOUNGER (1804–1891)
*Psyche Lamenting the Loss
of Cupid*, 1847
Marble, height incl.
integral base 152.4cm
RCIN 2044

LUDWIG SCHWANTHALER
(1802–1848), sculptor;
JOHANN BAPTIST STIGLMAIER
(1791–1844), founder
Ludwig, Duke of Bavaria
(d.1347; left) and *Otho, Duke
of Bavaria* (d.1253; right)
from the *Twelve Historical
Rulers of Bavaria, c.*1842
Gilt bronze on gilt and
patinated bronze bases,
heights excl. bases
49.1 to 53cm
RCIN 21933.2

These are two of
twelve statuettes
depicting the
historical rulers of Bavaria,
given to the Queen in 1843.
Although we might assume
this gift to be far closer to
Prince Albert's taste, the
Queen was in fact delighted
with it. 'My beloved one
had the immense kindness
of giving me what I had
so long wished for, 12
statuettes, copied in small
from Schwanthaler's gilt
statues in the Throne Room
at Munich.'

SÈVRES MANUFACTORY;
JEAN-CHARLES DEVELLY
(1783–1849), figure painter;
PIERRE HUARD (active
1811–1847), ornament
painter
*Casket (La toilette des femmes
dans les cinq parties du monde)*,
1842
Porcelain and gilt bronze
27.5 x 41 x 27cm
RCIN 1464

Foreign rulers presenting
gifts to Queen Victoria and
Prince Albert took careful
account of their individual
tastes. The Queen, for
instance, liked porcelain-
mounted furniture and was
therefore delighted to
receive this richly decorated
casket from King Louis-
Philippe of the French.

Mounted with hand-painted
Sèvres porcelain plaques, the
larger panels depict women
from each of the world's
continents getting dressed.
The lid (right) shows a scene
from a European boudoir
with two women attended
by their maids.

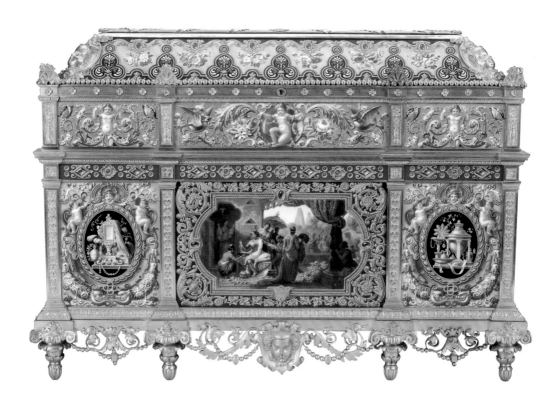

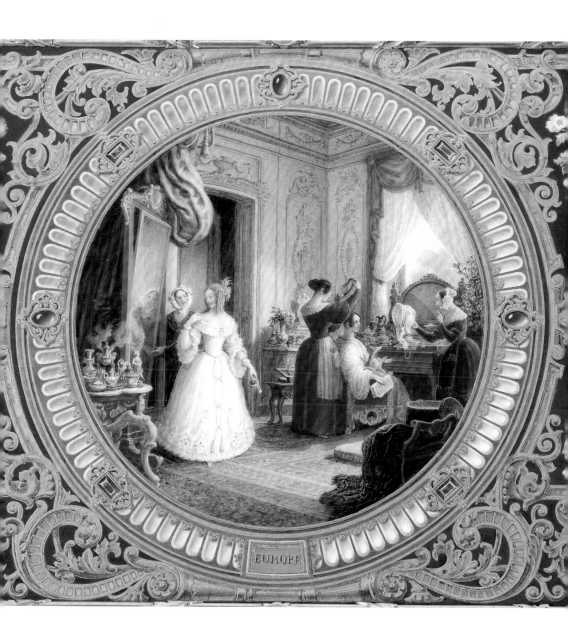

EUROPE

W. T. COPELAND & SONS LTD;
WILLIAM BEATTIE
(1829–1864), modeller
Burns and Highland Mary,
1851
Unglazed porcelain (Parian
ware), 47.8 x 37 x 24cm
RCIN 34729

This group – showing the
Scottish poet Robert Burns
with his beloved Mary
Campbell – is made from a
form of porcelain that was
intended to imitate carved
marble. Known as Parian
ware, the new process
was soon used to make
affordable, scaled-down
reproductions of works of
art. Both Queen Victoria and
Prince Albert repeatedly
allowed copies of privately
commissioned sculpture
to be made in this way,
and were enthusiastic
collectors themselves.

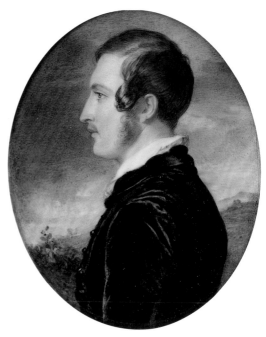

SIR WILLIAM ROSS (1794–1860)
Queen Victoria, 1841
Watercolour on ivory
laid on card, 12 x 10cm
RCIN 422422

The Queen's fondness for portraiture,
particularly of loved ones, meant that the
royal collection of miniatures expanded
dramatically during her reign. Although
the painter of these two early portraits,
Sir William Ross, produced more than
140 works for the couple, he developed
no lasting rapport with the Queen, who
rather cruelly noted in her Journal that
she thought him 'a very silly man and
very tedious to sit to'.

SIR WILLIAM ROSS (1794–1860)
Prince Albert, 1840
Watercolour on ivory
laid on card, 9.8 x 7.4cm
RCIN 421462

ROBERT HILLS and
JOHN HENRY SAUNDERS
(*active* 1850–1900)
*Buckingham Palace:
the Picture Gallery, c.*1873
Albumen print,
15.3 x 19.8cm
RCIN 2103640

A fascinating view of
the Picture Gallery at
Buckingham Palace in
the 1870s, this photograph
shows the matching frames
commissioned and designed
by Prince Albert to minimise
the amount of shadow cast
on the paintings. Other
improvements to the Gallery
ordered by the Prince
included the introduction of
a central row of skylights to
increase daylight, and the set
of chandeliers for night-time
viewing.

WILLIAM BAMBRIDGE
(1819–1879); FRANCES
SALLY DAY (*c.*1816–1892);
J.J.E. MAYALL (1813–1901);
CAMILLE SILVY (1834–1910)
A folding portfolio containing
portraits of Queen Victoria and
Prince Albert, 1859–61
Albumen *cartes-de-visite*, each
photograph approx. 9 x 5.4cm
RCIN 2914920

In the 1850s the Queen
became an enthusiastic sitter
to and collector of *carte-de-*
visite portraits. These small
photographs, mounted on
card, were produced in large
numbers. They would then
be distributed among friends
and family, and arranged
in albums – all activities
enjoyed by the Queen. In
1860 the Queen agreed to
pose for *cartes-de-visite* for sale
to the public. They proved
immensely popular.

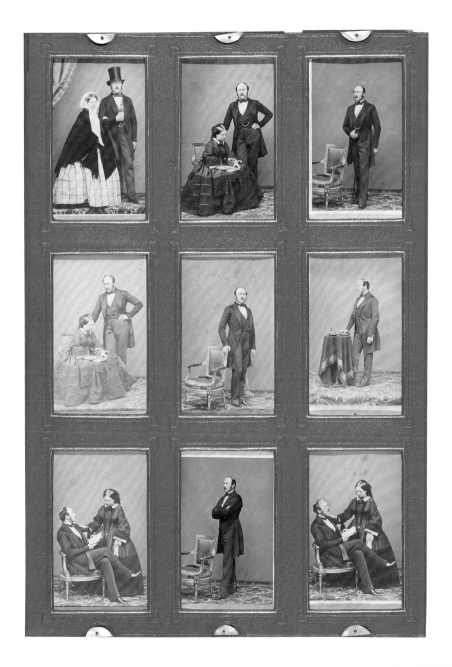

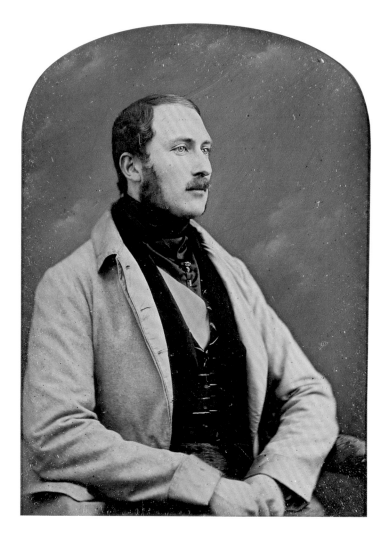

WILLIAM EDWARD KILBURN
(1818–1891)
Prince Albert, 1848
Hand-coloured
daguerreotype, 8.6 x 6.3cm
RCIN 2932487

The daguerreotype was an early form of photography in which a unique, positive image was captured on a highly polished silver-coated copper plate. Some daguerreotypes, like this portrait of Prince Albert, were then hand-coloured to create images of startling immediacy. The Prince was an early enthusiast for the medium and probably first encountered it in 1842, just three years after the process was announced to the public by its inventor, Louis Daguerre.

William Edward Kilburn (1818–1891)
The Chartist meeting on Kennington Common,
10 April 1848
Daguerreotype,
10.7 x 14.7cm
RCIN 2932484

This daguerreotype, purchased by Prince Albert, records the immense crowds at one of the Chartist rallies held in South London in 1848. Calling for political reform, and spurred on by the recent February Revolution in France, the Chartist movement was seen by many

as a terrifying threat to the established order. Fears were so great that on the eve of the meeting pictured, the Duke of Wellington stationed troops across London and the royal family were removed to Osborne House on the Isle of Wight.

DON JUAN, COMTE DE
MONTIZON (1822–1887)
*Obaysch the Hippopotamus,
London Zoo*, 1852
Salt print laid on card,
11.4 x 14.7cm
RCIN 2905523

This photograph of Obaysch,
the first hippo to arrive in
England, was seen by the
Queen and Prince Albert
at the inaugural exhibition
of the newly formed
Photographic Society in
1854. Their support of the
exhibition, and the artistic
and educational potential
of this new medium, was
widely reported in the press.
The Queen described de
Montizon's images of the
animals at London Zoo
as 'the finest of all the
specimens' on show.

ROYAL ARTISTS

THE TREMENDOUS PLEASURE that Queen Victoria and Prince Albert took in their patronage of the arts, and their keen sense of discernment, were rooted in the fact that both were artists in their own right. From the age of eight the Queen had taken drawing lessons from established artists, proving herself an enthusiastic pupil; and in later life she was always keen to improve her skills. Artists she commissioned were often asked to give her instruction. She learnt painting in oil from Winterhalter (see opposite), for example, and engaged both Landseer and Hayter to teach her and the Prince the art of etching. An occasional frustration the Queen suffered, however, was that her position as Sovereign meant she had little opportunity to sketch in public. But her children, and the retreats of Osborne and Balmoral, provided her with ample subject-matter. Prince Albert was also a competent draftsman, and, since many of his etchings are based on drawings made by the Queen, they offer us a glimpse of the way in which art played a part in their daily life. His chief skills, however, lay in musical composition, architectural and interior design (see chapter 3, *Home*) and sculpture. His love of animals resulted in some fascinating works realised with the help of professional artists and craftsmen. Unsurprisingly, the royal couple's enthusiasm as artists was passed down to their children, especially to their first-born, Victoria, Princess Royal.

QUEEN VICTORIA
A scene from 'Der Hahnenschlag',
1852
Oil on canvas, 63 x 47.4cm
RCIN 403663

Combining the aspects of life Queen Victoria enjoyed most – family, picturesque costume, theatre and art – this work shows the royal children in a scene from the German comedy they performed in 1852. In the foreground stands Princess Helena in *lederhosen* as the hero Wilfred, with Princess Louise as his sweetheart, Lieschen. The other royal children are in the background. The Queen had recently taken lessons in oil painting from Winterhalter, and this picture echoes his double portrait of the Prince of Wales and Prince Alfred (see p. 45).

PAGES 164–5:
QUEEN VICTORIA
'View from my sitting room window at Osborne', 1848
(detail; p.168)

QUEEN VICTORIA
'View from my sitting room window at Osborne', 1848
Watercolour with traces of bodycolour, 16.8 x 24.7cm
RL K26, fol. 33

This landscape shows the view across the Solent that Queen Victoria enjoyed from her Sitting Room at Osborne House. The Queen had been working hard on her watercolour technique, following instruction from her tutor W. L. Leitch, who insisted she pay particular attention to creating a distinct foreground, middle ground and distance – here perfectly captured in a simple but luminous view of the grassy slope, trees and coastline.

QUEEN VICTORIA
Archie and Annie MacDonald,
1850
Watercolour and slight traces
of bodycolour over pencil,
20.2 x 26.4cm
RL K27, fol. 72

Archie and Annie MacDonald
were the children of one of
Prince Albert's gillies, or
gamekeepers, who came
south to run the royal ken-
nels at Windsor. Here Queen
Victoria paints them with
two of the royal pets, the
dachshund Daphne and the

'Scotch terrier' Fancy. The
inscription at the bottom
notes the work was begun in
November 1845 but not
finished until March 1850,
indicating that the Queen
took trouble to assemble and
complete each individual
element of a composition.

PRINCE ALBERT, etcher,
from a drawing by
QUEEN VICTORIA
*The Princess Royal and the
Prince of Wales*, 1843
Etching on Japanese paper,
trimmed sheet 14.8 x 16cm
RCIN 816729

Both the Queen and the
Prince took lessons in
etching. This is a print-
making technique in which a
specially coated metal plate
is scored with various sharp-
pointed tools to create an

image. Prince Albert, whose
collection of etching tools
still survive (right), and
Queen Victoria often made
prints using each other's
drawings for inspiration.
It was an attractive way for

the royal couple to
collaborate, and, since the
nursery was their main
subject, these prints give us
an intimate view of their
family life together.

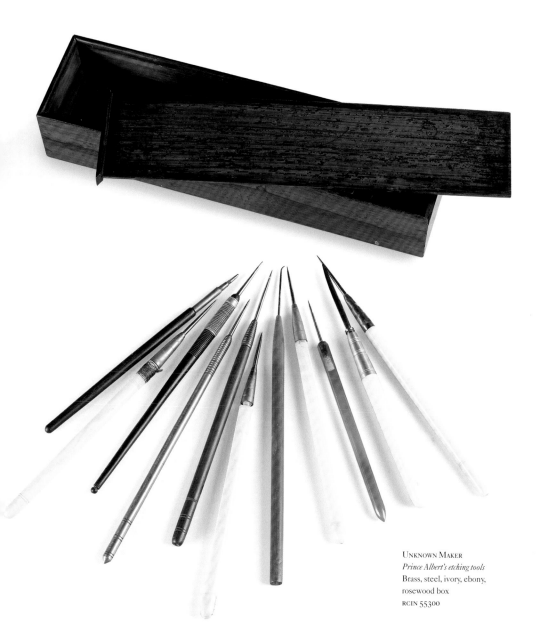

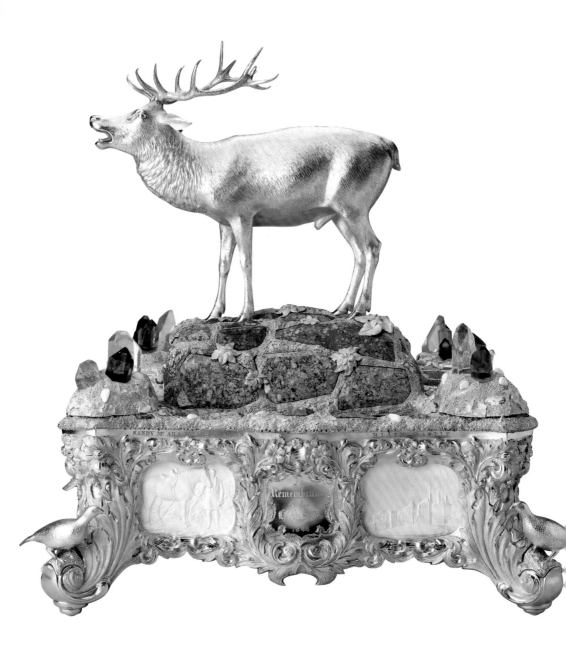

PRINCE ALBERT, designer;
KITCHING & ABUD, jewellers;
CHARLES RAWLINGS and
WILLIAM SUMMERS, retailers
The Atholl Inkstand, 1844–5
Silver, silver gilt, granite,
marble, quartz, deer's teeth,
cairngorm and amethystine
quartz, 48 x 48 x 35.3cm
RCIN 15955

Prince Albert designed this
elaborately decorated
inkstand in memory of the
royal couple's stay in the
Scottish Highlands in
September 1844. For the
Queen, the trip was 'a little
Arcadia for a few weeks',
while the Prince declared
that the Highlands 'act as a
tonic to the nerves and
gladdens the heart of a lover
like myself of field sports and
of nature'. The manufacture
of the stand, using stones
collected by the Prince and
teeth from stags he had shot,
was one of many pieces for
which, in the role of designer,
he brought a number of
artists and craftsmen
together.

ALBERT EDWARD, PRINCE OF
WALES (1841–1910), with
EDWARD CORBOULD
(1815–1905)
I know my position, Sir!, 1854
Pen and ink over pencil with
watercolour and touches of
bodycolour, 17.5 x 25cm
RL K477, fol. 25

Albert Edward, Prince of
Wales, was given drawing
lessons from an early age
and was later tutored by
E.H. Corbould, a water-
colourist often commissioned
by the Queen and Prince
(see pp. 95 and 187). In this
study Corbould placed his

own humorous drawing of a
military man on the left for
the thirteen-year-old Prince
to copy. It was this imagina-
tive approach to teaching
that made Corbould a
favourite among the royal
children.

VICTORIA, PRINCESS ROYAL (1840–1901)
The Princess Royal's fan, 1856
Leather leaf painted in watercolour, bodycolour and gold over pencil, pierced and carved ivory guards and sticks, the guards backed with mother of pearl, guard length 26.7cm
RCIN 451134

Victoria, the Princess Royal, was fifteen years old when she decorated this fan for her mother's thirty-seventh birthday. The name VICTORIA is spelt out in gold letters, each one accompanied by a bouquet of flowers beginning with that letter (for example, violets for V), while swags joining each bouquet are inscribed with the names and birthdates of the Queen, Prince Albert and their first eight children. The central oval contains the figures of Fame and Peace – the latter being particularly appropriate, as the Crimean War had ended just a few months previously.

VICTORIA, PRINCESS ROYAL (1840–1901)
The Entry of Bolingbroke, 1857
Watercolour, bodycolour and gum arabic over pencil,
47.1 x 41.6cm
RL K498

This lively watercolour was painted by Victoria, Princess Royal, after she had seen Charles Kean's production of Shakespeare's *Richard II* in London in 1857. She recalled, 'I do not know when a thing made such an impression on me.' It shows a scene reported by one of Shakespeare's characters, the Duke of York, describing the triumphant entry of Bolingbroke into London following the abdication of the King (Act V, Scene 2).

You would have thought the very windows spake, So many greedy looks of young and old Through casements darted their desiring eyes Upon his visage …

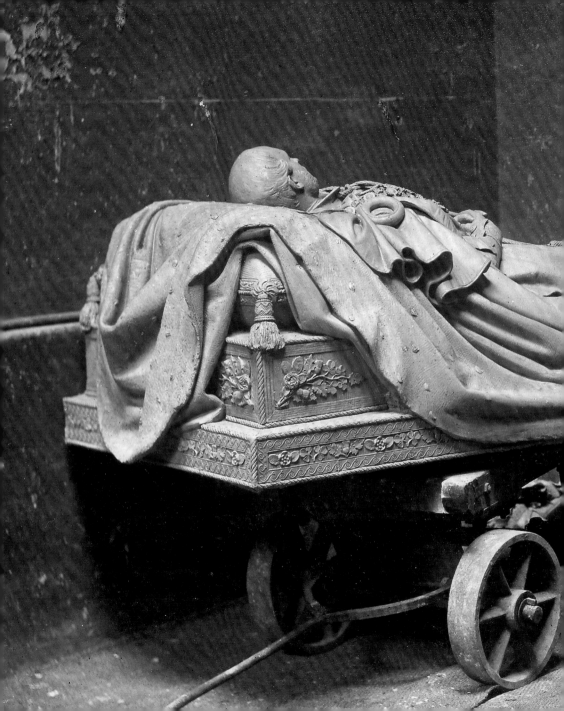

IN MEMORIAM

PRINCE ALBERT'S SENSE of duty and painstaking diligence in completing every task he undertook – from aiding the Queen with affairs of state to the minutiae of his many artistic projects – began to take a toll on his health. In 1859, the year of the Prince's fortieth birthday, mental and physical exhaustion contributed to the first in a series of fevers and digestive disorders that became increasingly severe. In December 1861, while at Windsor Castle, the Prince succumbed to typhoid fever, dying on the night of 14 December. The catastrophic effect of the Prince's death on Queen Victoria is well known. But what is less often remembered is that, even in the midst of her grief, the Queen found the strength and resourcefulness to push through all manner of artistic commissions to commemorate the life, achievements and artistic tastes of her beloved Consort. Some, such as the Mausoleum at Frogmore, were based on ideas the couple had probably already discussed. Others, such as the Albert Memorial in Kensington Gardens, were projects where, despite her protestations that without the Prince she had no taste or design skills of her own, the Queen still showed her mettle as a patron of the arts. However, without Prince Albert that sense of partnership – of shared passion for art and for each other – was lost. One of the most active periods in the history of royal patronage in Britain was at an end.

J.B. BROWN, after JAMES CARTER (1798–1855), with letterpress by C. PROVOST
Windsor Castle from Eton Play-Fields, with notice of the bulletin announcing the death of the Prince Consort, 14 December 1861
Steel engraving with letterpress, sheet 25 x 20.3cm
RCIN 700279

This hastily assembled bulletin was the first to announce the news of Prince Albert's death on 14 December 1861. He was forty-two years old. The four signatories are the Prince's physicians.

PAGES 176–7:
UNKNOWN PHOTOGRAPHER
Marochetti's plaster version of the effigy of Prince Albert awaiting delivery to the Mausoleum at Frogmore, 1862 (detail)
RCIN 2931373.b

WINDSOR CASTLE FROM ETON PLAY-FIELDS.

Windsor Castle, Saturday Night,

December 14, 1861.

" His Royal Highness the Prince Consort became
rapidly weaker during the evening, and expired
without suffering at ten minutes before Eleven
o'clock.

"JAMES CLARK, M.D.
"HENRY HOLLAND, M.D.
"THOMAS WATSON,
"WILLIAM JENNER."

C. Provost, Printer, 11, High Street, Windsor.

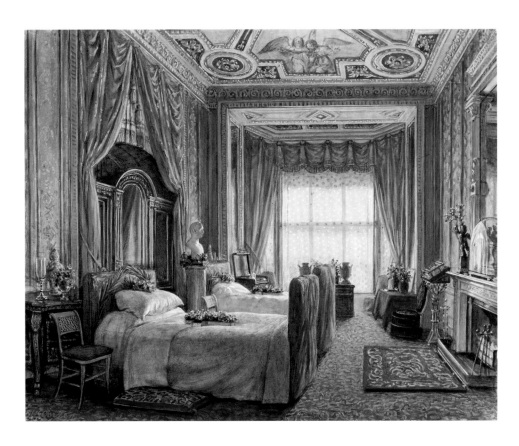

WILLIAM CORDEN
THE YOUNGER (1819–1900)
*Windsor Castle: The Blue Room,
looking toward the window,*
*c.*1864
Watercolour and bodycolour
over pencil, 26.7 x 32.9cm
RL 19815

The Blue Room at Windsor
Castle, where Prince Albert
spent his final days, was
carefully preserved after
his death. It was not kept,
the Queen insisted, as 'a
Sterbe-Zimmer [death room]
– but as a living beautiful

monument'. She commis-
sioned Ludwig Gruner to
decorate the ceiling and she
had a memorial bust of the
Prince, carved by William
Theed, placed between
the beds.

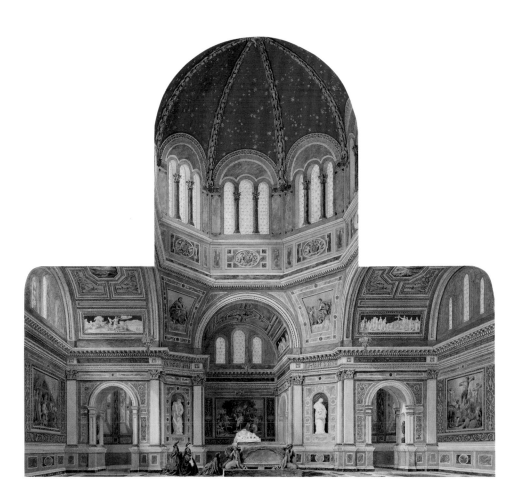

ARTHUR CROFT (1828–c.1901)
Frogmore: Interior of the Royal Mausoleum, looking towards the Chapel of the Altar, 1863
Watercolour and bodycolour with gold paint and gum arabic over pencil,
42.2 x 47.2cm (arched top)
RL 19739

In Britain, sovereigns and their consorts were usually buried in Westminster Abbey or in St George's Chapel, Windsor. But Queen Victoria, probably acting on an idea already discussed with the Prince, followed the German tradition of building a private mausoleum. Erected in the grounds of Frogmore House, in the Home Park just southeast of Windsor Castle, the interior was decorated in a style inspired by the Prince's beloved Raphael. In this presentation watercolour, the figure of Queen Victoria is shown kneeling beside the Prince's effigy.

CARLO, BARON MAROCHETTI
(1805–1867), modeller;
ELKINGTON & CO., founder
Albert, Prince Consort, *c*.1865
Bronze, 19 x 87 x 39cm;
ebonised wood plinth
14 x 87 x 45cm
RCIN 45185

The Queen commissioned
Marochetti to create the
effigy of the Prince for the
Mausoleum at Frogmore,
although she left her eldest
daughter, Victoria, now the
Crown Princess of Prussia,
chiefly in charge of its design.
The work, shown here in
a reduced reproduction,
depicts the Prince swathed
in his Garter robes and as if
asleep. 'It has a sweetness
and calmness, happiness and
repose,' the Princess wrote
to her mother, 'which, while
they cause one's tears to flow,
make one feel soothed and
comforted.'

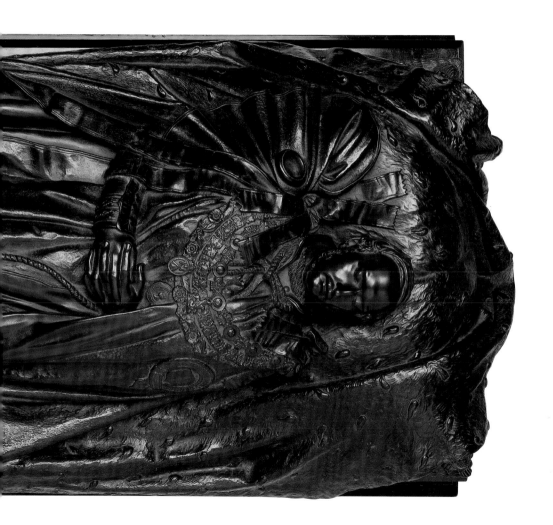

SIR GEORGE GILBERT SCOTT
(1811–1878)
Design for the Memorial to the Prince Consort, Kensington Gardens, 1863
Watercolour, 119 x 174cm
RL 21531

Of the numerous memorials erected to Prince Albert following his death, the monument in Kensington Gardens in London is the most famous. Queen Victoria devised the terms of the commission and, following a competition in which she showed her usual acuity and judgment, she eventually selected the plans submitted by the architect George Gilbert Scott. However, as time passed the Queen felt an increasing lack of confidence in her opinions and described the burden of making decisions on the monument as 'terrible'.

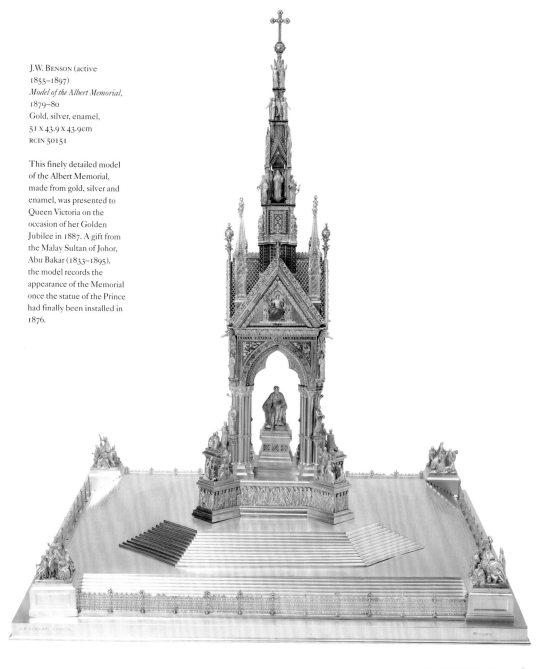

J.W. BENSON (active
1855–1897)
Model of the Albert Memorial,
1879–80
Gold, silver, enamel,
51 X 43.9 X 43.9cm
RCIN 50151

This finely detailed model
of the Albert Memorial,
made from gold, silver and
enamel, was presented to
Queen Victoria on the
occasion of her Golden
Jubilee in 1887. A gift from
the Malay Sultan of Johor,
Abu Bakar (1833–1895),
the model records the
appearance of the Memorial
once the statue of the Prince
had finally been installed in
1876.

Ich habe einen guten Kampf gekämpfet, ich habe den Lauf vollendet, hinfort ist mir beigelegt eine Krone der Gerechtigkeit.

EDWARD CORBOULD
(1815–1905)
Memorial to the Prince Consort,
1863
Watercolour and mixed
media, 75.7 x 61cm
RL 27595

This watercolour by
E.H. Corbould presents
the Prince in armour at
the centre of a fictional
altarpiece, like a Christian
knight of old. The portrait
was based on a portrait
miniature by Robert
Thorburn, an image which
also appears on Gruner's
1851 Jewel Cabinet (see
p.47). But here Corbould
shows the Prince sheathing
his sword, indicating that
the battle of life is over.
The Queen had this work
inserted into the door of
the Blue Room at Windsor
Castle (see p.180), where the
Prince had died.

PRINCE ALFRED (1844–1900)
*Queen Victoria and Princess
Alice with a bust of the Prince
Consort, March 1862*
Albumen print, 7.8 x 5.5cm
RCIN 2900540

The eighteen-year-old Prince
Alfred took this photograph of
his mother and Princess Alice
just three months after the
death of his father. The black
mourning dress worn by the
Queen and Princess contrast
with the glowing white of the
marble bust of the Prince that
stands above them. The
Queen, who was convinced
she would not be long in
joining her beloved Consort,
looks up at his image with
longing. In her grief, their
shared passion for art, which
had taken the form of so many
portraits and souvenirs of
their life together, provided
her with some comfort. But it
was to be forty years before
the Queen was laid to rest
beside the Prince at the
Mausoleum at Frogmore.

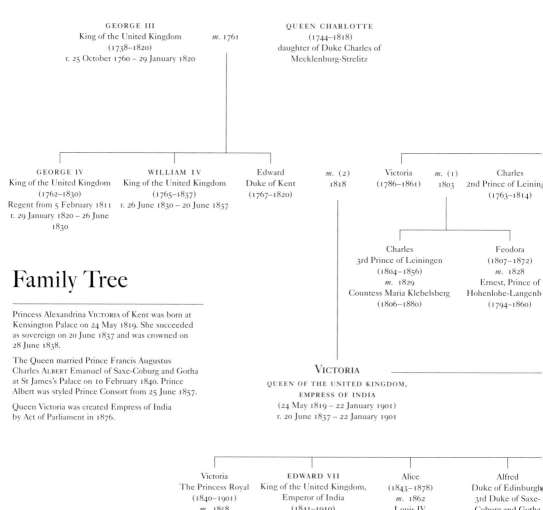

GEORGE III
King of the United Kingdom *m.* 1761
(1738–1820)
r. 25 October 1760 – 29 January 1820

QUEEN CHARLOTTE
(1744–1818)
daughter of Duke Charles of
Mecklenburg-Strelitz

GEORGE IV
King of the United Kingdom
(1762–1830)
Regent from 5 February 1811
r. 29 January 1820 – 26 June
1830

WILLIAM IV
King of the United Kingdom
(1765–1837)
r. 26 June 1830 – 20 June 1837

Edward
Duke of Kent
(1767–1820)

m. (2)
1818

Victoria
(1786–1861)

m. (1)
1803

Charles
2nd Prince of Leining
(1763–1814)

Charles
3rd Prince of Leiningen
(1804–1856)
m. 1829
Countess Maria Klebelsberg
(1806–1880)

Feodora
(1807–1872)
m. 1828
Ernest, Prince of
Hohenlohe-Langenb
(1794–1860)

Family Tree

Princess Alexandrina VICTORIA of Kent was born at
Kensington Palace on 24 May 1819. She succeeded
as sovereign on 20 June 1837 and was crowned on
28 June 1838.

The Queen married Prince Francis Augustus
Charles ALBERT Emanuel of Saxe-Coburg and Gotha
at St James's Palace on 10 February 1840. Prince
Albert was styled Prince Consort from 25 June 1857.

Queen Victoria was created Empress of India
by Act of Parliament in 1876.

VICTORIA
QUEEN OF THE UNITED KINGDOM,
EMPRESS OF INDIA
(24 May 1819 – 22 January 1901)
r. 20 June 1837 – 22 January 1901

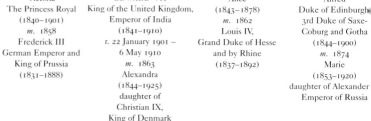

Victoria
The Princess Royal
(1840–1901)
m. 1858
Frederick III
German Emperor and
King of Prussia
(1831–1888)

EDWARD VII
King of the United Kingdom,
Emperor of India
(1841–1910)
r. 22 January 1901 –
6 May 1910
m. 1863
Alexandra
(1844–1925)
daughter of
Christian IX,
King of Denmark

Alice
(1843–1878)
m. 1862
Louis IV,
Grand Duke of Hesse
and by Rhine
(1837–1892)

Alfred
Duke of Edinburgh
3rd Duke of Saxe-
Coburg and Gotha
(1844–1900)
m. 1874
Marie
(1853–1920)
daughter of Alexander
Emperor of Russia

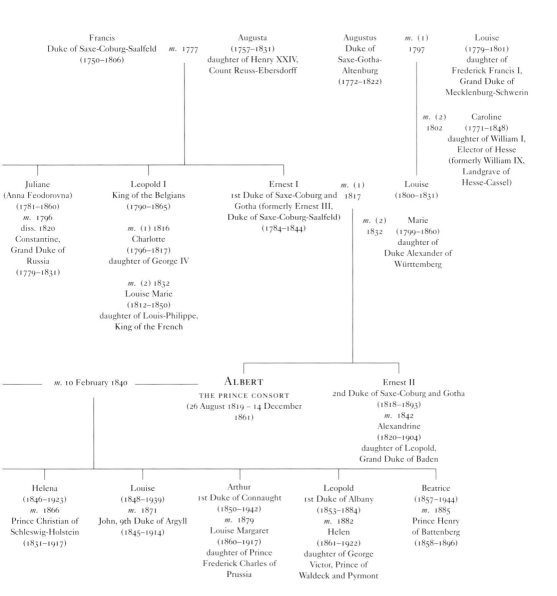

Francis
Duke of Saxe-Coburg-Saalfeld *m.* 1777
(1750–1806)

Augusta
(1757–1831)
daughter of Henry XXIV,
Count Reuss-Ebersdorff

Augustus
Duke of
Saxe-Gotha-
Altenburg
(1772–1822)

m. (1)
1797

Louise
(1779–1801)
daughter of
Frederick Francis I,
Grand Duke of
Mecklenburg-Schwerin

m. (2)
1802

Caroline
(1771–1848)
daughter of William I,
Elector of Hesse
(formerly William IX,
Landgrave of
Hesse-Cassel)

Juliane
(Anna Feodorovna)
(1781–1860)
m. 1796
diss. 1820
Constantine,
Grand Duke of
Russia
(1779–1831)

Leopold I
King of the Belgians
(1790–1865)

m. (1) 1816
Charlotte
(1796–1817)
daughter of George IV

m. (2) 1832
Louise Marie
(1812–1850)
daughter of Louis-Philippe,
King of the French

Ernest I
1st Duke of Saxe-Coburg and
Gotha (formerly Ernest III,
Duke of Saxe-Coburg-Saalfeld)
(1784–1844)

m. (1)
1817

Louise
(1800–1831)

m. (2)
1832

Marie
(1799–1860)
daughter of
Duke Alexander of
Württemberg

—————— *m.* 10 February 1840 ——————

ALBERT
THE PRINCE CONSORT
(26 August 1819 – 14 December
1861)

Ernest II
2nd Duke of Saxe-Coburg and Gotha
(1818–1893)
m. 1842
Alexandrine
(1820–1904)
daughter of Leopold,
Grand Duke of Baden

Helena
(1846–1923)
m. 1866
Prince Christian of
Schleswig-Holstein
(1831–1917)

Louise
(1848–1939)
m. 1871
John, 9th Duke of Argyll
(1845–1914)

Arthur
1st Duke of Connaught
(1850–1942)
m. 1879
Louise Margaret
(1860–1917)
daughter of Prince
Frederick Charles of
Prussia

Leopold
1st Duke of Albany
(1853–1884)
m. 1882
Helen
(1861–1922)
daughter of George
Victor, Prince of
Waldeck and Pyrmont

Beatrice
(1857–1944)
m. 1885
Prince Henry
of Battenberg
(1858–1896)

Index of Artists and Makers